the photographe
guide to
Death Valley

Where to Find Perfect Shots and How to Take Them

Shellye Poster

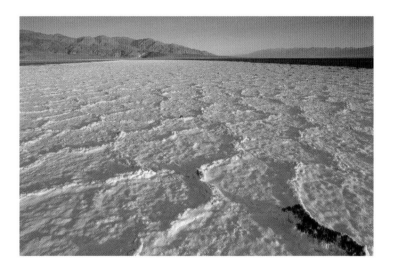

THE COUNTRYMAN PRESS
WOODSTOCK, VERMONT

*To my dad, for introducing me
to the marvels of the natural world.
And for Aunt Patti, who always
believed this was possible.*

ISBN 978-0-88150-789-8

Cover and interior photos by the author
Book design and composition by S. E. Livingston
Maps by Paul Woodward, © The Countryman Press

Published by The Countryman Press,
P.O. Box 748, Woodstock, VT 05091

Distributed by W. W. Norton & Company, Inc.,
500 Fifth Avenue, New York, NY 10110

Printed by Versa Press, Peoria, Illinois.

10 9 8 7 6 5 4 3 2

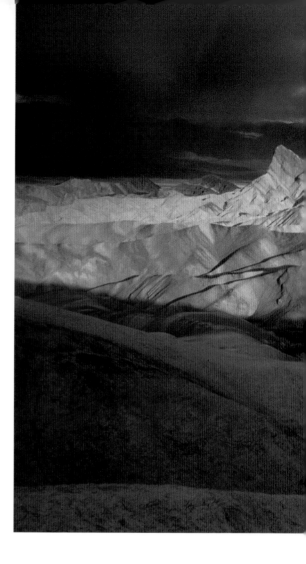

Title Page: Salt Pan in morning
Right: Manly Beacon at sunrise

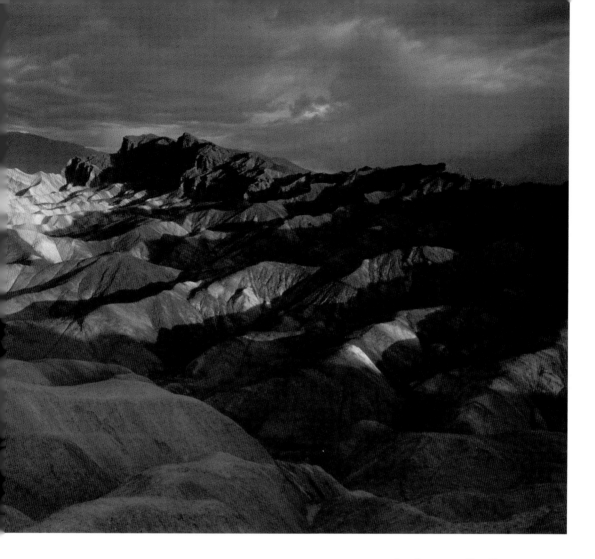

Acknowledgments

At The Countryman Press, to Kermit Hummel for setting this project into motion and Jennifer Thompson for seeing everything through to completion. And to Dale Evva Gelfand for her constructive feedback and editing expertise.

Special thanks to my Death Valley consortium: Aaron, Ruth, David, Steve, Carre, and DJ.

To Rod Barbee and David Middleton for their encouragement, inspiration, and guidance.

This book would not have been possible without the help of numerous individuals and organizations—specifically: Amy Nguyen, Daphne Chu, The Death Valley '49ers, Glenn Thureson, Goldwell Open Air Museum, Ivar's Seafood Bar in Ballard, Kathy Smith, Kurt Bittle, Sean Nork, The Ewbank Family (Susan, Mark, Madeline, and Mitchell), Trevor Pronga, Troy Wyche, and Willard Hatch. This list could go on and on, so let me just say that I also wish to thank all others, past and present, who have contributed insights, enthusiasm, knowledge, and patience.

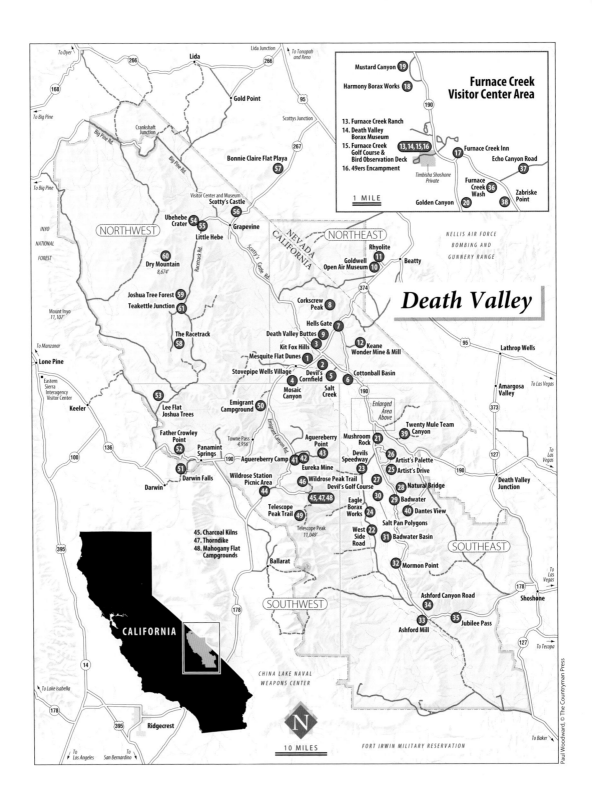

To Dyer
266
Lida
Lida Junction
266
To Tonopah and Reno

168
Gold Point
95

To Big Pine
Scottys Junction

Crankshaft Junction
Big Pine Rd.
Big Pine Rd.
267

To Big Pine

Bonnie Claire Flat Playa
57

Visitor Center and Museum
Scotty's Castle
56

Furnace Creek Visitor Center Area

Mustard Canyon 19

Harmony Borax Works 18

13. Furnace Creek Ranch
14. Death Valley Borax Museum
15. Furnace Creek Golf Course & Bird Observation Deck
16. 49ers Encampment

190

13, 14, 15, 16

17 Furnace Creek Inn
Echo Canyon Road 37

Timbisha Shoshone Private

Furnace Creek Wash 36

Golden Canyon 20

Zabriske Point 38

1 MILE

INYO NATIONAL FOREST

Ubehebe Crater 54 55
Little Hebe
Grapevine

NORTHWEST

60 Dry Mountain 8,674'

Racetrack Rd.
Scotty's Castle Rd.

NEVADA
CALIFORNIA

NORTHEAST

Rhyolite 11
Goldwell Open Air Museum 10
Beatty

NELLIS AIR FORCE BOMBING AND GUNNERY RANGE

Death Valley

Joshua Tree Forest 59
Teakettle Junction 61

Mount Inyo 11,107'

The Racetrack 58

Corkscrew Peak 8
Hells Gate 7
Death Valley Buttes 9
Kit Fox Hills
Mesquite Flat Dunes 1 3
2
12 Keane Wonder Mine & Mill
374
95
Lathrop Wells

To Manzanar

Lone Pine

Eastern Sierra Interagency Visitor Center

Keeler

53
Lee Flat Joshua Trees

Emigrant Campground 50

Stovepipe Wells Village 4
Devil's Cornfield
Mosaic Canyon
Salt Creek
5
6
Cottonball Basin

190
Enlarged Area Above

Amargosa Valley
373

To Las Vegas

136

Father Crowley Point 52
Panamint Springs

Towne Pass 4,956'
Emigrant Canyon Rd.

Aguereberry Point 43
Aguereberry Camp 41 42
Eureka Mine

Mushroom Rock
Devils Speedway 23
21
39 Twenty Mule Team Canyon

26 Artist's Palette
25 Artist's Drive

127
To Las Vegas

100

51
Darwin Falls
Darwin

190
Wildrose Station Picnic Area 44
Wildrose Peak Trail 46
Devil's Golf Course
45, 47, 48

27
30
Eagle Borax Works
24
28 Natural Bridge
29 Badwater
40 Dantes View

Death Valley Junction

395

Telescope Peak Trail 49

45. Charcoal Kilns
47. Thorndike
48. Mahogany Flat Campgrounds

Telescope Peak 11,049'

West Side Road
22
Salt Pan Polygons
31 Badwater Basin

SOUTHEAST

To Las Vegas

Ballarat

32 Mormon Point

178

CALIFORNIA

SOUTHWEST

Ashford Canyon Road 34

178
To Las Vegas
Shoshone

14

33 Ashford Mill
35 Jubilee Pass

127
To Tecopa

178
395
Ridgerest

To Lake Isabella

To Los Angeles
To San Bernardino

CHINA LAKE NAVAL WEAPONS CENTER

N
10 MILES

FORT IRWIN MILITARY RESERVATION

To Baker

Paul Woodward, © The Countryman Press

Contents

Introduction .7
Using This Book .9
How I Photograph Death Valley11

Northeast
Stovepipe Wells .25
1. Mesquite Flat Dunes26
2. Devil's Cornfield27
3. Kit Fox Hills27
4. Mosaic Canyon28
5. Salt Creek28
6. Cottonball Basin29

Toward Beatty .30
7. Hell's Gate30
8. Corkscrew Peak30
9. Death Valley Buttes30
10. Goldwell Open Air Museum31
11. Rhyolite .32
12. Keane Wonder Mine and Mill33

Southeast
Furnace Creek .35
13. Furnace Creek Ranch36
14. Death Valley Borax Museum
 at Furnace Creek Ranch36
15. Furnace Creek Golf Course
 Bird Observation Platform37
16. '49ers Encampment38
17. Furnace Creek Inn38
18. Harmony Borax Works39
19. Mustard Canyon40

Badwater Road41
20. Golden Canyon41
21. Mushroom Rock44
22. West Side Road45
23. Devil's Speedway45
24. Eagle Borax Works45
25. Artist's Drive46
26. Artist's Palette47
27. Devil's Golf Course48
28. Natural Bridge49
29. Badwater .50
30. Salt Pan Polygons50
31. Badwater Basin—South of Badwater52
32. Mormon Point53

33. Ashford Mill53
34. Ashford Canyon Road55
35. Jubilee Pass55
**CA 190 East and South of the
 Furnace Creek Inn**56
36. Furnace Creek Wash56
37. Echo Canyon Road57
38. Zabriske Point57
39. Twenty Mule Team Canyon59
40. Dante's View60

Southwest
Emigrant Canyon Road63
41. Aguereberry Camp64
42. Eureka Mine65
43. Aguereberry Point66
44. Wildrose Station Picnic Area66
45. Charcoal Kilns68
46. Wildrose Peak Trail69
47. Thorndike Campground70
48. Mahogany Flat Campground70
49. Telescope Peak Trail70

Panamint Springs72
50. Emigrant Campground72
51. Darwin Falls73
52. Father Crowley Point73
53. Lee Flat Joshua Trees75

Northwest
Grapevine Canyon77
54. Ubehebe Crater77
55. Little Hebe77
56. Scotty's Castle78
57. Bonnie Claire Flat Playa80

Backcountry Adventures81
58. The Racetrack81
59. Joshua Tree Forest81
60. Dry Mountain81
61. Teakettle Junction81

Death Valley Wildflowers
Wildflower Overview87
Wildflower Photography Tools and Tips88

Favorites .93
Resources .95
Suggested Reading96

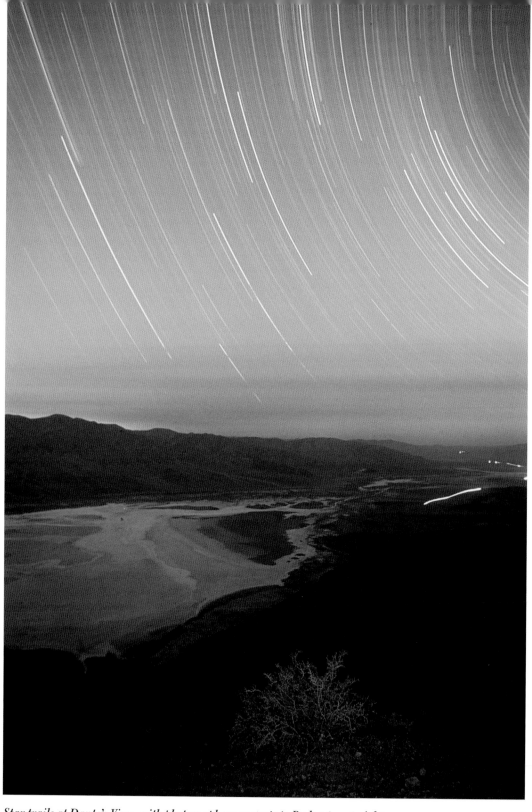

Star trails at Dante's View, with photographers en route to Badwater at night

Introduction

Death Valley expands across the upper reaches of the Mojave Desert. Without a doubt, all the desert stereotypes and trying experiences of the California Gold Rush pioneers and prospectors who encountered this place in the mid-1800s are conjured up by the name "Death Valley." With attractions named Badwater, Devil's Golf Course, and Hell's Gate, how could they not? Foreboding monikers for sure—but worthy of such a revered reputation today? Not a chance. With proper planning and preparation, Death Valley is a photographer's desert paradise!

The area is rich with geological beauty and cultural history. Death Valley comprises scenic vistas, expansive salt flats, colorful badlands, intricate texture, and magic hours to die for. Borax works, stagecoaches, abandoned mines, and ghost towns—even a full-fledged castle!—are just some of what you'll encounter. And when precipitation conditions are just right, desert wildflowers carpet Death Valley's terrain. All of these subjects speak to both color and black-and-white imagery, and they are waiting for you and your camera.

Located mostly in California and a tiny triangle in Nevada, Death Valley National Park spans over 3.3 million awe-inspiring acres. Originally cited as a national monument, the California Desert Protection Act of 1994 expanded Death Valley's boundaries and elevated its status, creating the largest national park in the lower 48 states. Park boundaries are accessible 24/7, however, being a public-use land with protected resources, the National Park Service promotes the caveat of "leave no trace" other than your footprints—and rightfully so since desert ecosystems are extremely fragile. We outdoor photographers stand out to other travelers. Setting good examples with the attention we garner ensures that the scenery, including the native flora and fauna—which have adapted quite successfully to this harsh arid climate—will endure for future generations and repeat visits.

As you plan your trip and collect the necessary gear, don't forget to budget enough time and money for traveling within the park. Death Valley is big, and few spots enjoy prime light at both sunrise and sunset. Moving around the park, you'll find it's not uncommon to cover over 100 miles in a day—some days even more. Should you choose to stay in lodging outside the park's boundaries, you'll need to factor that in, as well. The closest major city is Las Vegas—about a three-hour drive. Los Angeles, San Diego, and Reno are also within a day's driving distance, roughly five, six, and seven and a half hours, respectively.

On my first trip to Death Valley, I crossed paths with some snowbirds who were in the park with grandchildren during their annual spring break visit. We exchanged colorful conversation about the area and its many facets. One key piece of advice they offered: "Don't try to do it all this time. Save something for the next trip." Their comments continue to resonate. Each time I head home, my heart pangs, and voices in my head tell me, "I need to shoot such-and-such in black and white. The light will be better in the fall (or spring or summer). Next time I'll head over *there* for sunset shots." While I'm not about to guarantee that this book will make you a full-fledged desert rat, at the very least it will set you up for an enjoyable Death Valley visit. And with a little luck you'll also take home some wonderful photographs! Who knows? Maybe you'll start hearing your own voices and return year after year as I do.

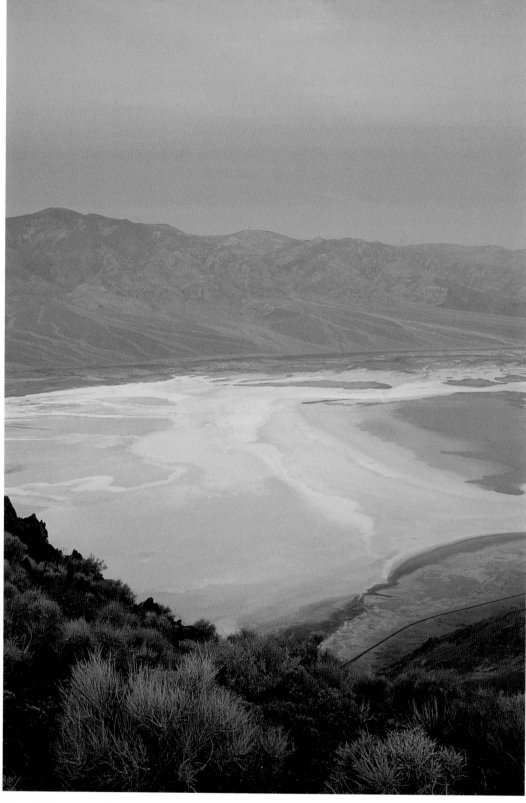

Dante's View at sunrise

Using This Book

This book is designed to make the most of your Death Valley photography adventures. Getting you to the best spots at the most desirable times and helping you create rewarding images is the overriding theme.

Photographers plan their trips and observe locations differently than casual tourists. They aim to see a landscape at its most flattering and exciting conditions and at the best time of day—and ideally capture such moments inside their cameras. Since this is a location guide written by a photographer for photographers, it's my hope that you'll maximize shooting opportunities by discerning descriptions and selecting sites that pique your personal interest.

On the other hand, it's equally important to mention what this book *is not*. For starters, please don't hope for a camera-operation manual or a digital photography/postprocessing guide. While for certain sites I mention in this book I offer ideas about exposure, filters, depth of field, composition, night photography, white balance, and file manipulation, the short discussions are no substitute for the many excellent books available on these respective topics. Likewise, this text is not a backcountry manual. Discussions about truly remote excursions are best left to titles recommended by the Death Valley Natural History Association. And aside from the Racetrack and Aguereberry Point, most locations don't involve extended travel on high-clearance 4WD roads. Thankfully, Death Valley's most photogenic sites are accessible via passenger car—many without leaving paved roads.

You'll gain the most from this guide by reading the preliminary sections first. Discussions of baseline concepts such as lighting, weather, composition, equipment, and safe desert travel are positioned up front to best assist you in trip preparation. The chapters in this book are devoted to the park's regional corridors and its wildflowers. Each regional chapter contains seasonal ratings and a sidebar highlighting distinctive attributes. Numbered site/subject narratives cover my thoughts on seasonality, lighting patterns, surrounding topography, lens choices and vehicle accessibility, and flower potential where applicable. And while this book doesn't unveil any hidden photo hot spots in Death Valley, it does offer fresh mindsets for approaching iconic sites and initiating your personal interpretation of the terrain.

Other resourceful strategies and timing recommendations noted as "Pro Tips" are sprinkled throughout the book. Occasionally "Cautions" reiterate key safety and/or readiness recommendations. Maps and directions are also provided to orient your journeys, though I highly recommend a detailed park map to supplement this guidebook; especially if you'll be hiking or traveling any rough road surfaces. The "Wildflowers" chapter offers insight on blooming timelines and creative compositions, and special icons within the text indicate places with lovely wildflower displays. The final section is a compilation of my favorites from Death Valley and the nearby vicinity—some photo oriented, some not, though all very subjective and strictly my opinion, of course.

Additionally, text discussions are intended for photographers using single-lens reflex (SLR) cameras—either film or digital—with tripods as they are essential equipment for serious work. Individuals using point-and-shoot models will benefit most from composition suggestions and recommended midday locations, though I

expect you'll eventually graduate to an SLR system. If you're shooting medium or large format, skip straight to the site descriptions.

Focal-length recommendations are included for many subjects. As a rule, suggestions are made in general terms such as wide-angle or telephoto because lenses function differently when attached to different camera formats. Unless you're shooting a full-frame digital SLR, your digital camera is not rendering images in 35mm format. In most digital SLR models, the sensor is smaller than a piece of 35mm film. During digital capture, the camera essentially pares down the coverage area of a 35mm frame. It's also why digital SLR cameras magnify the focal lengths of lenses designed for film cameras and what prompted companies to manufacture special digital-only format lenses

for digital SLR bodies. Wide-angle focal lengths for film and full-frame digital cameras range from 18mm to 35mm; for other digital models that span is 12 to 24mm. Normal focal lengths are 35 to 70mm for film and full-frame digital and 24 to 50mm for other digital models. Short telephotos cover the 80 to 200mm range for film and 50 to 135mm for digital. Telephoto for film is 300mm or longer; for digital, about 200mm or longer.

I hope this guide inspires you to seek out Death Valley's exceptional character and photogenic reserves. Synch yourself with this landscape, heed its calling, and discover the inexhaustible lure that has appealed to so many dreamers. In the process you just might form an instinctive bond with this unique landscape—and achieve some striking imagery, too!

Rainbow over the Funeral Mountains

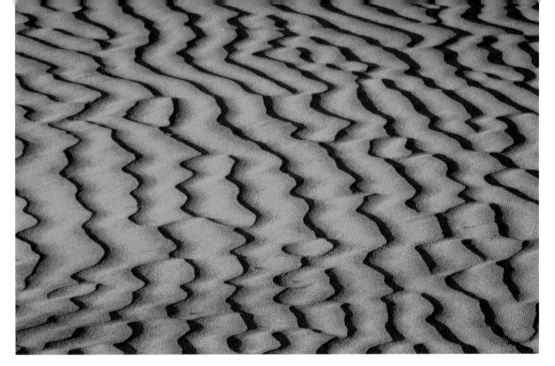

Dune ripples convey texture and patterns

How I Photograph Death Valley

Sometimes I think of Death Valley as another kind of Vegas: Selecting a location in this expanse of boundless beauty is always a moderate gamble. Conditions can be considerably different when you arrive at your chosen destination than what they were at your motel that morning, and more than likely distance and/or travel time will make it difficult to backtrack to benefit from another locale. Yet like gambling casinos, Death Valley turns out winners everyday —sometimes big winners. And both gambling and creativity involve risk, which means you have to play to win. Likewise, those who win more—or, rather, lose less—are often master observers. They learn to read signs, recall past experiences, and apply intuition. They've developed a sense of when to roll, hold, and fold. Putting yourself in the field offers opportunities to hone observation skills and accrue atmospheric awareness—both of which translate to knowledge and photographic payoffs. Plus, the more you're in the field, the more the odds improve that you'll be in place during prime conditions. Since luck is often the attentive photographer's optimum instructor, set your alarm clock, pick your poison, descend into the darkness, and see what the day deals you.

Light and Weather

Light and weather go hand in hand, though with photographers it's all relative. As a rule, some degree of "bad" weather usually translates to "good" light—a concept that's often summarized with the "no rain, no rainbows" punch line.

By definition, photography is depicting with light. Whether your capture medium is film or CompactFlash, you're rendering the effects of light as it disperses across subjects channeled into your camera's viewfinder. Good light can transform an otherwise uninspiring subject into a jackpot. By the same token, bad light can crash a potential scene faster than hearing: "House wins." The upside is you can learn to read light—and unlike counting cards in Vegas, it's completely encouraged!

Seasonal Considerations

Spring is the most popular season in Death Valley. Mild temperatures and the inexhaustible lure of flowers are annual givens. In addition, the Panamint Range usually flaunts snowcap into April. During summer months, intense sunshine, triple-digit temperatures, and cloudless blue skies make it tough to shoot at low elevations. Plus, the valley's heat holds haze, obscuring views and flattening magic hours. Conditions and temperatures in fall are very similar to spring. The most notable difference is the absence of mountain snow, although it could be a short-lived difference if autumn storms blow through during your visit. Winter skies routinely unveil some of the best photo conditions, including dramatic cloud cover, low sun angle, and freshly dusted mountain ranges.

Magic Hours

Generally speaking, these windows are the hour after sunrise and the hour before sunset. Lighting quality is typically warm and gentle, and an absence of harsh contrast translates to more manageable exposures and complimentary lighting conditions. In addition, the sun's low angle presents many opportunities for tasteful side and backlighting effects. To make the most of these opportunities, arrive on time, and work the light as long as it lasts.

Sidelighting creates dramatic shadows

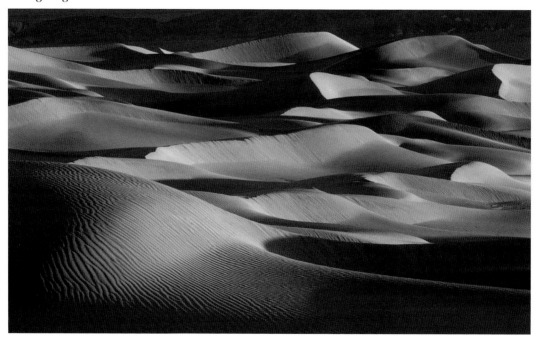

Sidelighting

Anchoring your compositions with the juxta-position of glowing edges and luscious shadows is a proven method to conjure up a sense of depth. It's an especially effective tool for showcasing the contour of sand dunes, though it works throughout the rocks, ridges, and ripples of desert terrain.

Backlighting

When translucent subjects are illuminated from behind, complimentary halos or shafts of warm, glowing light result. Cacti and sagebrush are promising candidates for backlighting and are plentifully distributed throughout Death Valley. I favor late-afternoon light over early-morning light for this effect—possibly because late-afternoon light feels warmer. Also, atmospheric particles increase throughout the day, further enhancing luminosity.

Clouds

In any season, desert cloud cover is a gift, especially during the magic hours. Clouds are nature's light modifiers, serving as reflectors and diffusers. In the best lighting situations they often perform both roles. Pinch yourself if the conditions are stormy and the sky features ominous clouds—then thank Mother Nature. Such conditions are a rarity in Death Valley, so you'll want to capitalize on the occasion.

Dynamic Light

Be watchful for the unexpected, especially during El Niño patterns or any time the National Park Service Morning Report mentions a significant threat of precipitation. Despite previously clear skies or considerable cloud cover, atmospheric conditions can change rapidly, unveiling the dramatic moments that outdoor photographers live for. At times like these, knowing your gear is invaluable. When spectacular light unfolds, it's easy to feel breathless and become

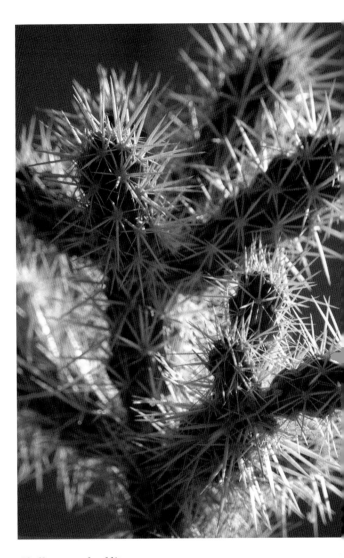

Cholla cactus backlit

consumed with what's appearing in front of you. Still, you'll want to maintain broad-spectrum awareness of what's happening as even better things may be brewing behind you. Work the lighting as long as possible, and if the sky is spectacular, be sure to include lots of it. And even if circumstances don't permit you to photograph the atmospheric excitement, relish the moment and record it in your mind's eye.

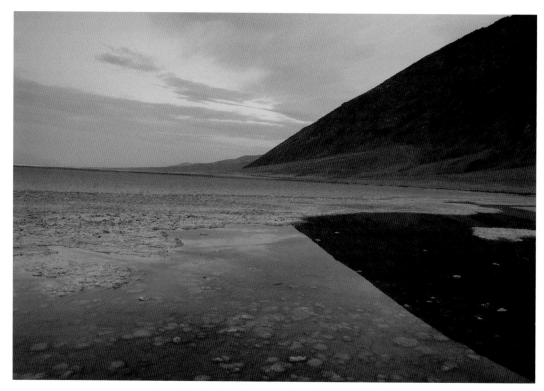

Contrast the Badwater reflection at the edge of morning twilight with . . .

Blue Skies

In the desert, clear blue skies aren't nearly as interesting as blue skies with clouds. In fact, from late spring to early fall, it's typical to have days with zero clouds. And though it requires more creativity to shoot against bolts of blue, pleasant images are still possible. One approach is to face north and counterbalance a dominant object of interest against the solid sky.

Twilight Time

Death Valley's delicate shades at dusk and dawn have styled some of my favorite desert scenes. During the 30-minute span before sunrise and after sunset, stand with the sun behind you and watch for the essence of Earth shadow while the sun hovers below the horizon. As skies radiate shades of indigo and rose, and the haunting geology below recedes into tints of lilac and peach, you'll be poised to capture the most vibrant colors of the day.

Bad Light

A persistent dilemma in outdoor photography is locating interesting compositions beneath glaring midday sun or chalky overcast skies. Either situation usually translates to lackluster landscape scenes, with harsh shadows and/or apathetic color palettes as well as reduced texture and detail. Thankfully, Death Valley presents some options for midday photography. During overcast conditions, avoid the sky, and focus on compact themes such as exploring oxidized-metal and weathered-wood surfaces. Under bright-blue skies, compose facing north, and try your hand at interpreting geological patterns of the alluvial fans. In the event

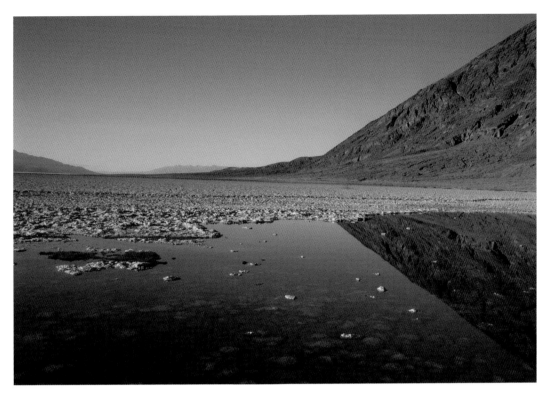

. . . the same location in midafternoon

that these options sound unappealing, consider allocating the photographic downtime to a soul-searching stroll or a rejuvenating nap.

Composition and Creativity

Discover Your Inner Desert Tortoise

These quintessential desert creatures hold an impeccable awareness of their environment. Unless you've happened upon some peaking dynamic light, I strongly encourage you to put yourself in touch with the terrain. Take a few moments to bond with your surroundings before grabbing your gear. Consider what strikes your eye, and contemplate perspectives that illustrate those attributes. Is it the stoic magnitude or poignant detail? Or perhaps the convergence of gleaming geology and deep shade? Given the chance, this seemingly monochromatic palette will reveal multiple personas. Should conditions require swifter evaluation, tote your gear to an appealing spot and begin by contemplating compositions with your camera off the tripod—remembering to explore various perspectives and focal lengths. Once you've selected an orientation for your subject, position your tripod and camera to accommodate the image you wish to create.

Portray Depth

Wide-angle lenses are wonderful tools for conveying dimension. This is especially true when crisp focus extends from foreground to infinity. Consult a hyperfocal guide or markings on your lens barrel to maximize sharpness. Positioning a wide-angle lens from lower perspectives is an effective way to articulate a feeling of breadth.

Create Foreground Interest

Compositions invoking such graphic elements such as leading lines invite a viewer into your image. Death Valley is plentiful with such prospects, including faults, flowers, geology, and dehydration designs.

Tackle Texture and Midrange Mementos

Use themes of repetition and simplicity to craft mesmerizing compositions. Sand dunes and alluvial fan patterns present many such opportunities and are effectively captured with comprehensive mid- to short-telephoto zooms.

Simplify Backgrounds

Nothing compromises a strong subject more than a weak background. Common culprits include twigs, hot spots, power lines, and unintentional convergence of negative space. Before tripping the shutter, take a moment to double-check the edges of your frame, and engage the depth-of-field preview button to detect any intruders or distracting brightness. In many cases it only takes a moderate camera adjustment to eliminate distractions and improve composition.

Understand Exposure

The best landscape scenes often feature lighting ranges beyond the latitudes of film or digital sensors. If you're not already using zone and spot metering techniques, I strongly encourage gaining familiarity with them. These cornerstone concepts will help you recognize and compensate for tricky lighting conditions by using graduated neutral-density filters or blending digital captures to craft tasteful exposures.

A Borax Museum buggy in color . . .

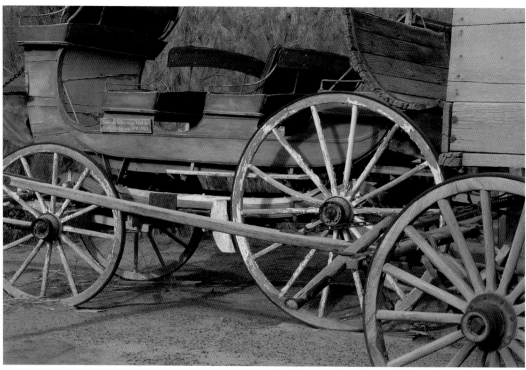

Consider Alternative Visions

Death Valley's abundance of texture and shadowing cater to black-and-white, sepia tone, and infrared imagery. Photo-editing software now allows photographers to reinterpret color imagery in monotone or duotone palettes. Even if you've never delved into these modes, the pioneer past and weathered storyboards of Death Valley may inspire you. Black-and-white film shooters with a 25 red filter might toy with the idea of infrared process. Though the Mojave landscape lacks the dreamy deciduous foliage featured in many infrared images, striated alluvial fans and whimsical clouds render remarkably well—plus you'll gain additional creative options in high-contrast midday lighting.

Regard the BIG Picture

Death Valley's spacious settings translate well to panoramic images. Select a normal or short telephoto lens, and place your camera on a level tripod. Snap a series of frames with about a 30-degree overlap, depicting 180 degrees or more, and merge them back home in a digital darkroom.

Essential Equipment

When it comes to gear, almost all photographers struggle with what is possible (their current budget/camera bag contents) and what is desirable (the latest and greatest). Yet it's important to remember that strong compositions result from choices made by the camera operator, not the camera. In the long run, a compact collection of familiar equipment treats

. . . and in sepia tone

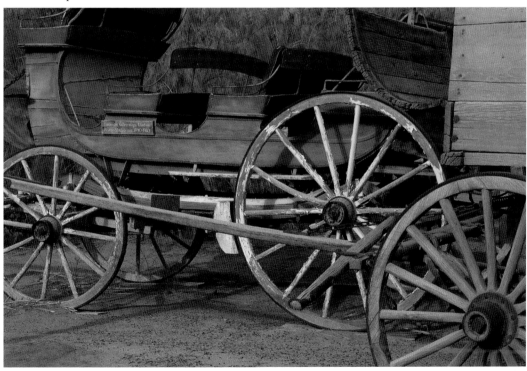

you better than toting a ton of technology. Odds also improve that you'll *get* the image because you didn't waste time deciding which lens to use or fumbling with unfamiliar gear. And while photographing Death Valley doesn't require any highly specialized equipment, I always have the following basics in tow.

Tripod and Cable Release

Placing your camera on a tripod and using a cable release empowers you to fine-tune compositions and deliberately position elements within the frame—especially with regard to clean edges, tasteful backgrounds, horizon placement, and low-light situations. In addition, you'll profit creatively by using lower ISO settings to boost color saturation and engaging slower shutter speed/high f-stop settings to convey depth. Using a cable release in combination with a camera's mirror lock-up or shutter delay feature is yet another way to reduce vibration. The bottom line is if you're serious about improving your photography, investing in a quality tripod and a cable release is indispensable. They will allow you to shoot higher-

Relic at Borax Museum

quality work in more situations. Plus, any gear you own will benefit as well. Even a modest lens will produce its sharpest results on a tripod.

Graduated Neutral-Density Filters

Because film and digital sensors lack the latitude to interpret scenes as our eyes do, they won't dependably record every scene. Thankfully there are graduated neutral-density filters, or ND filters—often referred to as "grads"—to lend a helping hand. These rectangular pieces of resin or glass allow photographers to rein in the lighting differential between a shaded foreground and bright sky or background. Graduated ND filters are available in different strengths and degrees of transition. Those shooting film will want to carry several grad filters. Digital shooters can sometimes benefit from using them as well. Yes, many photographers choose to combine files in a digital darkroom, and an increasing number of camera models possess functions to achieve similar results internally. But while it's possible to simulate the effect of graduated filtration in the Photoshopped digital world, I still prefer to create balanced exposures in the field as much as possible, even if I'm shooting digital.

Polarizing and Warming Filters

Polarizers are wonderful for filtering out reflections and haze. They also deepen blue skies and accentuate distinctive cloud formations, especially when you're facing north. Though polarizers are amazing tools, ultra wide-angle lenses and high elevations often skew their function, creating unbalanced and unrealistic skies. To minimize this effect, set the polarizer to your liking, and then back off a quarter turn or so. Other practical filters for working in desert locations are the 81A and 81B warming filters. These assist film shooters in subduing the bluish cast of midday overhead light. And as you might expect, the warming polarizer

blends the best of both filters into one. Comparable effects are also possible with photo editing software should you wish to warm up a scene after the fact. Similarly, digital shooters can offset a bluish cast in the camera by using shade or overcast white-balance settings.

Power Up

Regardless of your shooting medium, be sure to bring plenty of it. More recently, I've noticed memory cards stocked behind sales counters, though I wouldn't expect a wide selection or professional-grade film. Multiple batteries and charged backups are a must, especially if you're camping. (Public power outlets are sparse in Death Valley, and in peak seasons, I've encountered people hovering outside restrooms because their laptop is inside, plugged into a wall outlet and downloading images.) Better yet, consider getting a car adapter to juice up your electronic accessories.

Death Valley Decadence

Sunrises and Sunsets

Watching the world change colors in Death Valley is a spellbinding experience. The spacious skies unleash mesmerizing edge-of-day drama, including compelling clouds, pulsating color palettes, and soothing earth shadow. In addition, the terrain's texture revels during these timeframes. Work the 30 minutes before and 60 minutes after sunrise and 60 minutes before and 30 minutes after sunset to depict the best lighting. Though keep in mind that the *actual* time of a sunset or sunrise will vary according to your location, depending on the elevation and surrounding terrain.

Ghost Towns and Cultural History

Strewn across Death Valley's landscape are the remnants of mining municipalities and the enterprises of self-deluding shysters. Some of

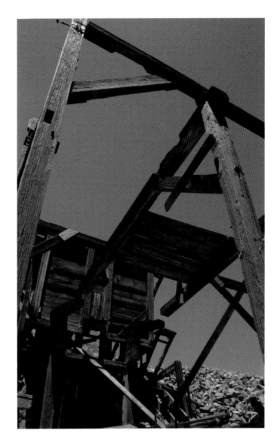

Cashier Mill remnants

these sites have been maintained with exquisite details intact while others are evolving canvasses of decomposition. In addition, modern reminders of Death Valley's muse are evident at Goldwell Open Air Museum.

Nighttime Skies

On evenings near a new moon, Death Valley becomes the ultimate planetarium. The Milky Way is front and center, and celebrated constellations appear close enough to touch. During brighter phases, moonbeams cast supernatural shadows across cultural sites and canyon walls. In either situation, conditions abound for enjoyable adventures with night photography.

Wildlife

Despite its desolate appearance, Death Valley is actually brimming with wildlife. Most species practice excellent camouflage, and many spend daylight hours underground or in burrows making wildlife photography quite the challenge. In addition, desert creatures tend to be small and skittish, so the slightest movements, like lens changes, usually send them off in a scurry. If photographing desert fauna still sounds appealing, come prepared with powerful glass and patience. Lizards can be found scampering about almost anywhere, and coyotes are frequently observed during morning and evening hours. Ravens patronize areas where human food scraps are a possibility. You're also likely to encounter grackles and sparrows around the valley's commercial communities. The endangered desert big horn sheep, on the other hand, are reclusive and prefer remote mountainous perches.

Hazards

Salt

Residue from the salt pan is extremely corrosive. After shooting anywhere near the salt pan, it's wise to wipe down your gear, footwear, or anything that made contact with the ground.

Devil's Golf Course with approaching storm

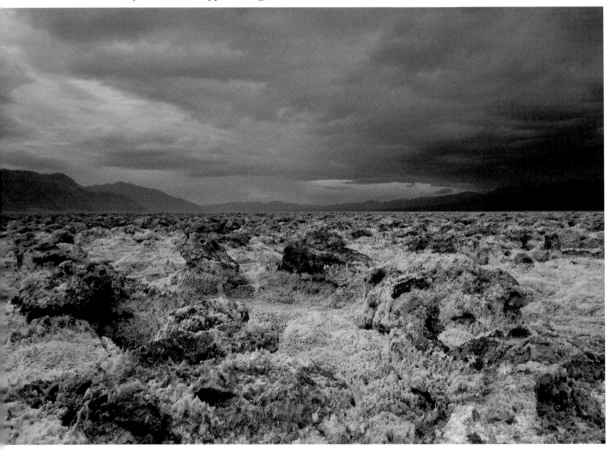

Sand

Despite being a goldmine of wonderful images, photographing in the sand dunes can quickly turn into a money pit. Be aware of sand grains that are generated by your movements or have adhered to your pack as they can endanger gear. Dropping a lens or camera into the sand may cost you several hundreds of dollars in cleaning costs. Carrying your equipment in a vest will significantly reduce your gear's proximity with the dune surface, minimizing your equipment's collection of sand grains. Tripods are at risk, too. Camera weight will push the legs into the dune surface, where sand can infiltrate the leg joints. Prevent the legs from sinking by attaching tripod snow shoes or placing plastic lids beneath the feet.

Wind

Dust devils are best photographed from a distance. Exercise special care in windy conditions. Better yet, give second thought to pulling gear out at all in blowing sand. Powerful gusts can upend tripods and carry debris that is painful to skin and damaging to gear. If you must shoot in blustery conditions, use lens hoods, and shelter your camera during lens and film/card changes.

Flash Floods

Death Valley vistas become especially thrilling when ominous clouds loom overhead. However, these same clouds can produce fierce storm activity and deadly flooding. Swift gushes can toss boulders and relocate cars as if they were toys. Should skies appear threatening, move to higher elevations, and avoid washes, gullies, and canyons.

Scorpions, Spiders, and Snakes . . . Oh, My!

Yes, these creepy critters make their home in Death Valley. Fortunately, they're reasonably stealthy and don't patronize top photo destinations. Avoid placing your hands beneath foliage or in shadowed areas, and odds are you'll be just fine. In all of my excursions, I've only encountered one rattlesnake, sunning itself several feet away.

Desert Safety

Yes, it gets hot here. And it's dry, too. This land of extremes holds the highest temperature reading in the western hemisphere (134 degrees) and averages less than 2 inches of annual rainfall. Temperatures begin flirting with triple digits by mid-May and often hold there into September. It's important to recognize your personal tastes and physical limitations—for some, 85 degrees—even in dry heat—is stifling, yet other individuals might deem that about perfect. Protecting your well-being with appropriate clothing and creature comforts will increase your field time—and likely your image quality, as well.

Remain Hydrated

Regardless of your personal preferences, you'll need to drink water to avoid dehydration and feel comfortable in this arid climate. One gallon of water per day is recommended, though summer conditions and physical activity—and perhaps your individual needs—will require more. Maintain hydration by drinking often—and preferably before you're actually thirsty. If you're working in the field, wrap up and head back once your water supply reaches the halfway point.

Arid and Unstable Terrain

Death Valley's terrain is loose and rocky. Choose your footing carefully, especially at overlooks and on sloping ground. Surface instability reinforces the importance of advance scouting and reduces stumbling in dim light. Plus, it increases your odds of securing the best spots!

Clothing

Unless you'll be visiting Death Valley in the throes of summer heat, bring a full range of options from T-shirts and shorts to fleece and insulating layers. For navigating rock-strewn gullies, sturdy ankle-high footwear is most supportive. And though you probably won't need a waterproof jacket, a nylon shell may come in handy on windy days. Speaking of wind, sunrise conditions at Dante's View and Zabriske Point can be chilly even when the daytime temperatures at Badwater are in the 60s and 70s. Building on the same premise, it's wise to anticipate frosty conditions at elevations above 2,500 feet in winter months.

Sunglasses and a brimmed hat top the accessories list. Death Valley sunlight is intense, especially in warmer temperatures. Without head protection, your scalp is subject to nasty sunburn. And don't forget your sunscreen! Avoid sunburn with liberal and consistent application of a high SPF sunscreen—baseball cap fans, don't forget the tops of your ears. Regular use of moisturizing hand cream should help keep your hands supple and avoid cracked skin. In the event of painful skin conditions, Johnson & Johnson's first-aid cream and liquid bandage products are my favorites.

Cell Phones

While travel comfort and options have improved greatly since the Twenty Mule Team days, not all modern technological advancements are at your disposal—specifically, cell phones. Death Valley's remote location and topography obscure tower signals. Simply put, don't go anywhere or attempt anything assuming a cell phone SOS will bail you out in this unforgiving environment.

Common Sense

Avoid unwelcome situations with advance preparation and responsible readiness. Carry extra water, food, and clothing at all times.

Consult ranger stations and the Death Valley Morning Report for current travel information during variable weather conditions. If you'll be venturing into the backcountry, let someone know your destination and intended itinerary—remembering to tell them when you've returned safely. Also, with the sole exception of the Eureka Mine, consider abandoned mining sites unsafe and unstable.

Travel Considerations

Vehicular Preparedness

It can't be said too often: you can avoid worst-case scenarios by traveling in a well-maintained vehicle. Keep your gas gauge at half full or more. Even better, top off the tank each evening to maximize the next day's excursion. The last thing you want is to have enticing conditions curtailed on account of low fuel. Also, aridness, salinity, and heat are tough on engines and tires. Roads can be lonely and sparingly traveled in off-peak seasons. Towing is expensive, and you're at the mercy of others—especially from backcountry roads. Death Valley provides numerous tanks containing radiator water, but that shouldn't prevent you from carrying some beyond your daily drinking rations.

Rental cars come with special considerations, too. Increasingly, more companies forbid their vehicles from leaving paved surfaces, and doing so may void contracts even when additional insurance is elected. If you have rented an SUV with intentions of backcountry travel, evaluate the tire quality, and verify that it is 4WD and not 2WD. For safety sake, casually confirm the accessibility of jack and spare before leaving the rental lot.

Backcountry Excursions

Reread the previous two topics, and heed any National Park Service suggestions or restrictions regarding unpaved roads. It's also important to note that not all SUVs are truly

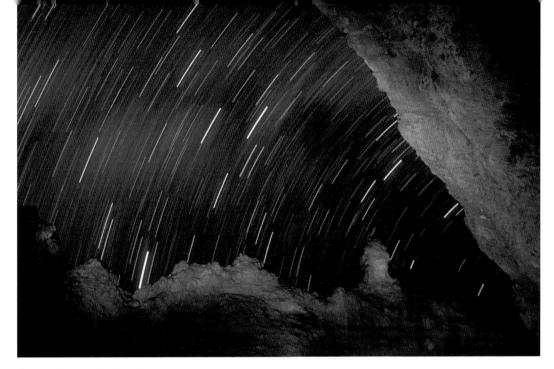

Star trails over Golden Canyon

high-clearance. Compact SUVs and station wagon models are lower to the ground, and their oil pan or underbelly may be jeopardized on backcountry roads. Additionally, many SUVs are not equipped with backcountry-quality tires. If you're uncertain about your vehicle's capability, ask a ranger to give it a quick assessment. A firsthand look may save you lots of time and money.

Driving and Parking Etiquette

Keep your eyes on the road, and obey road signage. Though this seems like a no-brainer, it's easy to get lost in the scenery or distracted by wildlife sightings. Also, *your* awareness might be the difference for another inattentive driver. Many Death Valley routes post speed limits above 50 mph, and drivers often exceed them, triggering single-car rollovers. If something strikes your fancy from the roadway, park safely along the shoulder, watch for traffic, and move closer to check it out.

Fill'er Up!

Expect to pay 30 to 50 cents per gallon above market rates within the park boundaries. As a government concessionaire, Stovepipe Wells will always have the best prices and I highly recommended topping off your tank when passing through the area. Gas at Scotty's Castle can be hit or miss, and at press time pumps had been inoperable for well over a year.

Time and Resource Allocation

Death Valley is likely to exceed your photo expectations—and possibly your trip's budget. Your lodging choices and length of stay will factor heavily into subject and location selections. Rising early enough to drive and set up at your morning destination is essential. If it's your first trip, attempt as many of the classics as you can: Zabriske Point, Badwater, Dante's View, Artist's Drive, Scotty's Castle, and the Mesquite Flat Sand Dunes. If time allows, you might try shooting the sand dunes more than once.

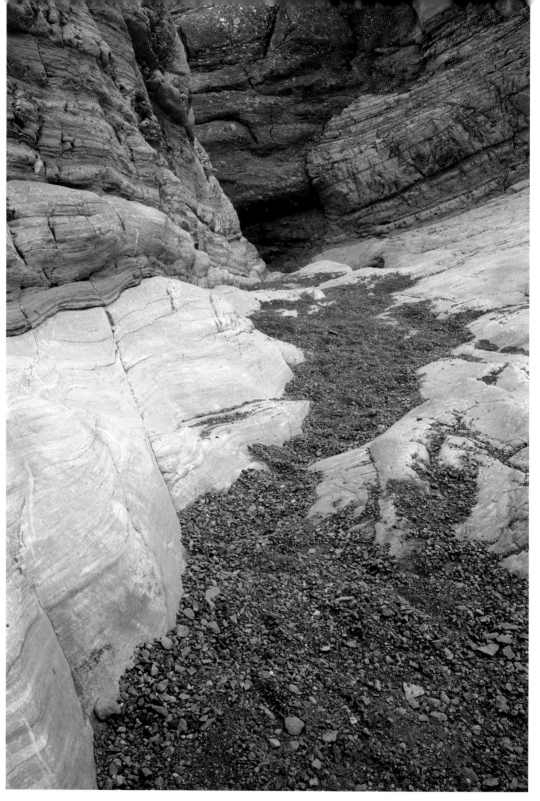

Mosaic Canyon wash

Stovepipe Wells

SEASONAL RATINGS: SPRING ★ ★ ★ SUMMER ★ FALL ★ ★ ★ WINTER ★ ★

General Description: Stovepipe Wells Village is a pleasant base camp for photographing the northern half of the park. It also offers more affordable lodging options for extended stays in Death Valley as its location equalizes the distances between many areas of the park, reducing travel time and maximizing your resources.

Directions: The Stovepipe Wells Village area borders both sides of CA 190 about 6 miles west of the Scotty's Castle Road. Drive time from the Furnace Creek area is about a half hour.

Specifically: Roadside elevations hover around sea level, plus or minus 100 feet. Canyon access roads climb a bit higher, ascending alluvial fan terrain. Wind is more prevalent at Stovepipe than Furnace Creek, and at times the gusts can be relentless, generating dust devils and kicking up loose rocks, sand, and tumbleweeds. If you're tent camping at Stovepipe or Emigrant, be sure to stake your tent. I've watched many a tent take flight in windy conditions.

Several **vintage vehicles** are sprinkled throughout the Stovepipe Wells grounds. Those of you who enjoy photographing mechanical subjects and textural studies will have a fun time here. Some of the possibilities include an old-fashioned fire engine, a stagecoach, hitching posts, and wagon wheels. Entertaining **ravens** and **grackles** perch about these subjects, and capturing these birds in the throes of social confrontation may yield some nice images, as well.

Where: The geographical center of Death Valley, along CA 190

Noted For: Sand dunes, eerie arrowweed formations, tenacious pupfish, colorful canyons

Best Times: Spring and fall

Exertion: Minimal to moderately challenging

Peak Times: March–April, early November

Accessibility: With the exception of Titus Canyon, all sites are accessible via passenger car, though some routes have dirt surfaces.

Facilities: Restrooms at Stovepipe Wells Village, Salt Creek, and Scotty's Castle Road–Daylight Pass Road junction

Parking: Dedicated lots at Stovepipe Wells, Salt Creek, Mosaic Canyon, and Scotty's Castle Road–Daylight Pass Road junction

Sleeps and Eats: Stovepipe Wells Village offers both traditional lodging and RV sites with full hook-ups, a well-stocked convenience store, and 24-hour gas pumps, both featuring the lowest price points inside the park boundary; National Park Service camping options include Stovepipe Wells, behind the convenience store, or free sites at Emigrant, another 10 miles west on CA 190 (two caveats about these campgrounds: Stovepipe Wells has no shade, and Emigrant's limited tent sites fill quickly in peak seasons); other area amenities include a restaurant, saloon, motel swimming pool, and ATM machine; nonmotel guests can shower and swim for a nominal fee (inquire at motel desk)

Sites Included: Mesquite Flat Dunes (a.k.a. Stovepipe Wells Dunes), Devil's Cornfield, Mosaic Canyon, Kit Fox Hills, Salt Creek

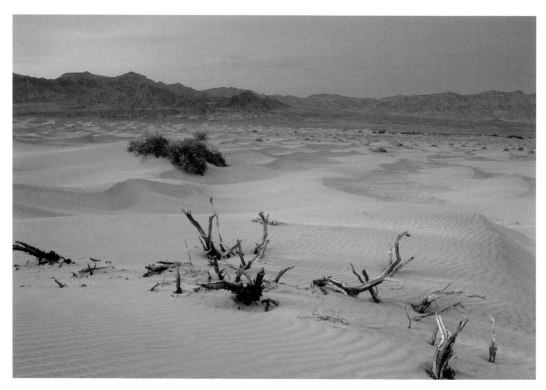

Morning twilight at Mesquite Flat (aka Stovepipe Wells) Dunes

Mesquite Flat Dunes (1)

Often referred to as the Stovepipe Wells Dunes, this overgrown sandbox is truly a photographer's delight! While this spot is most heavily visited during daytime hours, some consider it a spiritual evening destination around the nights of a full moon. But for the most part, overnights are a time for reversal. Much like shaking an Etch-a-Sketch screen, wind erases the previous day's events, making sunrise the premiere window for sand dunes photography. It's easy to spend lots of time here, especially if the light is good and the temperatures are comfortable. In fact, the sand dunes are worthy of return visits, often within the same stay. Anticipate an abundance of composition possibilities. Pack as much gear as you can comfortably carry, along with water and snacks, so you can make the most of the conditions. Clearer morning skies emphasize ripples and create intriguing shadows. Overcast skies flatten out the dunes, reducing their shape, lines, and definition. Many mornings it's hard to gauge what will unfold until you make the trek. Shadows will appear longest and most dramatic shortly after sunrise, about 15 to 30 minutes after the sun clears the Funeral Mountains.

The dunes alternate in height, with the tallest sitting about 2 miles out. Reaching the higher ridgelines takes more effort than you'd think and leaves a defacing trail of footprints in your wake—plus it's nice to position the big dune as bold subject against the northern horizon. Once among the dunes, my strategy is to minimize travel time and footprints by choosing a section not recently visited by others. A

prime spot is one that contains an area of textured slopes and lowlands surrounded by moderately high dunes with good vantage points. Begin atop a sizable dune, face north, and scope out leading lines and foreground elements for both multiple compositions and wider focal lengths. As the sun rises, enjoy photographing the rich color and texture that develop. Shoot as long as conditions seem appealing; at the same time, survey the sand for shadows and textures that might interest you. Move quickly to any alluring spots, especially if there are few or no clouds in the eastern sky. Once the higher surfaces have been tapped, slide down to depressions between the dunes. Here you'll encounter new studies in shadows, texture, and negative space. Eventually the sunlight will break across the dune crests, adding further dimension to the terrain.

Though it's unlikely you'll see many sand-dune residents, evidence of their nocturnal activity is all around you. If you're ever struggling to shoot "big picture" scenes, take a more introspective approach. Beetle and sidewinder trails make great macro and abstract shots. Since the dunes are largely monochromatic, this is a wonderful opportunity to shoot for black-and-white digital postprocessing.

Pleasant photo opportunities also exist during late-afternoon and sunset windows—with two catches. First, you'll be hiking out in a much warmer part of the day. Second, you'll encounter MANY more footprints—though they'll be easier to spot and avoid in your compositions. An upside is hazier evening skies that often yield pastel palettes and colorful northwest horizons that glow into twilight.

Cautions: Hiking across sand is taxing, especially with a pack of camera gear perched on your back. Factor in the arid climate and high temps to this mix, and your level of muscle fatigue and dehydration escalates. Newbies should take twice the amount of water and halve their amount of gear. Collecting incredible shots for your portfolio is cool—returning from the sand dunes as an EMT statistic is not.

Pro Tips: While overnight winds are fairly effective at erasing footprints, shifting entire dune formations is not as likely. For this reason it can be handy to piggyback sunset and sunrise shoots. Doing so enables you to scout formations and vantage points for morning compositions. Time your after-sunset return, and gauge accordingly for revisiting the next morning. Remember to take a flashlight or head lamp, too. Darkness falls quickly in Death Valley, especially on nights near a new moon. Once emerging onto the gravel shoulder, mark a big X so you'll know exactly where to park the next morning.

Directions: The dunes are located about 2.2 miles east of Stovepipe Wells Village on the north side of CA 190.

Devil's Cornfield (2) and Kit Fox Hills (3)

Devil's Cornfield is an excellent late-afternoon and sunset spot, especially if the day has gotten away from you, and there's not enough time to enter the dunes or reach spots farther south. Erosion has cast its plants into peculiar concoctions of stalk and sand. Despite lowered soil levels and exposed roots, this battered stand of arrowweed manages to prosper thanks to Salt Creek's shallow underground currents. You'll find taller, denser plants on the highway's north side. Case the area for an appealing foreground subject or, even better, a linear succession of them. As the sun drops, the plants cast a series of ominous blue shadows. These tones underscore the windswept textures and amber palette of the distant **Kit Fox Hills** to create striking studies of contour and depth. With sufficient

western clouds and light breaks, the arrowweed stacks may generate golden auras. Since these windows come and go quickly, you'll need to keep a read on the sky and possibly reset your gear to make the most of the opportunity. Being a little lucky won't hurt, either.

Directions: CA 190 intersects Devil's Cornfield about 0.5 mile west of the Scotty's Castle Road turnoff. Only shoulder parking is available, so ensure that your vehicle is safely off the pavement.

Mosaic Canyon (4)

Some slick-rock scrambling is required to access the polished narrows of Mosaic Canyon. After the first half mile or so, the peach-toned walls expand and the floor levels out. The surrounding marble walls are altered limestone of the Noonday Dolomite Formation. Light seeps into the canyon from late morning through early afternoon; otherwise, much of the area is shaded by the northern flank of Tucki Mountain. If you need inspiration to render this colorful geology, try juxtaposing the canyon walls against blue skies or explore its intimate sedimentary styling.

Devil's Cornfield and Kit Fox Hills

Directions: The turnoff for Mosaic Canyon is located on the left-hand side of CA 190, just a stone's throw west of the Stovepipe Wells Motel. The 2-mile-long gravel road is well-maintained and suitable for passenger cars. From the parking area, follow the informal footpath about 0.25 mile to the canyon's foyer.

Salt Creek (5)

The brackish waters of Salt Creek rise from a series of springs upstream from the parking area. During the winter and in a damper spring, look for its currents flowing alongside the parking area and access road before turning southward toward the valley. Despite the creek's high salinity and the sizzling summer temperatures, the endemic **Salt Creek pupfish** have adapted quite well. These tenacious creatures are descendants of a species of freshwater fish that once swam in ancient Lake Manly. The fish are most prolific during the spring months, when spawning peaks. Males are brightly colored and quite active—take a seat on the boardwalk, and watch for shimmering splashes as they defend territory and flip between pools. The water is clear and shallow enough that moderate telephotos and longer macros will enable you to capture the action. Insects and larvae also inhabit the creek, so it's not unusual to observe such birds as killdeer, common snipes, or sandpipers in the area. Light at Salt Creek is softest in the morning and often produces rewarding sunrise shots. Despite being a day-use area, it's usually accessible in time for morning twilight. Climb up the hills on the north side of the parking lot for vibrant northwest skies and views of Tucki Mountain.

Directions: From the Stovepipe Wells area, head east on CA 190. Continue 7 miles past the Scotty's Castle turnoff, and look for the Salt Creek turnoff on your right. The 1.1-mile graded dirt road is usually in good shape and

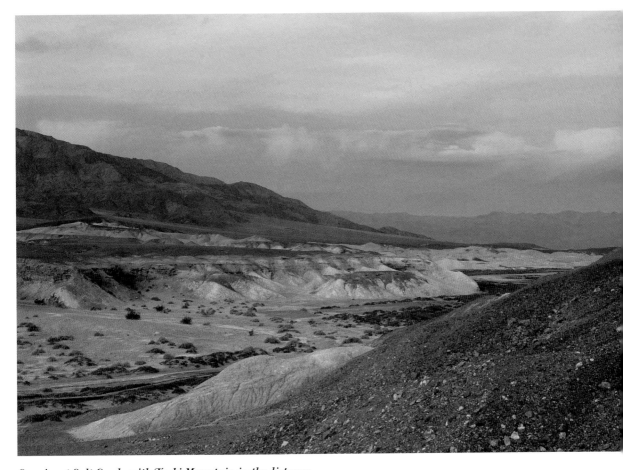

Sunrise at Salt Creek, with Tucki Mountain in the distance

suitable for all vehicles. From the parking area, it's just a short walk to the 0.5-mile-long boardwalk. The peaceful loop features several interpretive markers as it courses about the pools and occasional pickleweed stands.

Cottonball Basin (6)

Just south of Salt Creek is the crystallized expanse known as Cottonball Basin. Though not as appreciated or geometric as the Badwater polygons, these patterns are still worth exploring. Magic-hour lighting will accentuate the Salt Creek drainage patterns and tint the milky landscape with pastel shades. Dramatic clouds behind Tucki Mountain are common around sunset. To depict colors radiating along the western horizon, utilize graduated ND filters, or collect a range of digital captures. The ground surface can be spongy, and you may encounter sticky footing after recent precipitation.

Directions: From the Salt Creek access road, turn right on CA 190. Interesting spots are plentiful to the west and southwest between Salt Creek and the Beatty Cutoff Road. Safely park along the shoulder, and explore any patterns that interest you.

Toward Beatty

General Description: Eerie architecture, cultural sites, and alluvial fan geology dominate the subjects in this segment. Rising elevations give way to cooler temperatures and increased spreads of creosote bush and low-lying foliage.

Directions: The two major access routes are Beatty Cutoff Road, about 11 miles north of the Furnace Creek area on CA 190, and Daylight Pass Road, which becomes NV 374 after crossing the state line.

Specifically: Subjects range from distinctive geology to Death Valley's best preserved and most accessible gold mining site, Keane Wonder Mine and Mill. And just outside Beatty, Nevada, are Rhyolite and the Goldwell Open Air Museum.

Where: Central Death Valley, along the park's eastern border, moving away from the salt pan and heading toward Beatty, Nevada

Noted For: Sweeping views, cultural sites

Best Times: Spring and fall

Exertion: Minimal to challenging

Peak Times: March–April, early November

Accessibility: All sites accessible via passenger car; some routes have dirt surfaces

Parking: Dedicated lots at Hell's Gate and Keane Wonder Mine

Facilities: Restrooms at Hell's Gate

Sleeps and Eats: Nearest lodging and camping options inside the park are at Furnace Creek or Stovepipe Wells; outside the park, Beatty (about 10 miles) offers numerous motel and dining options

Sites Included: Keane Wonder Mine and Mill, Hell's Gate, Corkscrew Peak, Death Valley Buttes, Rhyolite, Goldwell Open Air Museum

Hell's Gate (7)

Traveling from Beatty, Hell's Gate is the first view indicating significant descension. Pleasant morning and evening shoots are possible here—despite the foreboding name. However, it takes interesting skies and above-average light to produce strong images. A rocky mound on the south side of Daylight Pass Road provides an elevated vantage point and possible foreground elements. Light winds are common here, so incorporating sharp foreground foliage can be a challenge—another reason to hope for colorful clouds. Hell's Gate is only a modest magic-hour spot, so I'd recommend shooting several magic hours at Mesquite Flat Dunes before rolling the dice here.

Also within view are two striking geological formations. To the northeast is the striated summit of **Corkscrew Peak (8)**. And looking northwest, it's hard to miss the distinctive profile of **Death Valley Buttes (9)**. With a rich, rust-tone palette, Corkscrew Peak has potential almost any time of day, though it looks especially grand against wispy late-afternoon clouds. The pyramid-shaped buttes are less-interesting subjects, though ascending them earns outstanding vantage points. From the Hell's Gate parking area, it's about 1.5 miles to summit the first butte. Though you won't get lost, an undefined trail and fragmented terrain make for a strenuous trek.

Directions: From Furnace Creek, travel westbound on CA 190 about 11 miles, and bear right onto Beatty Cutoff Road, continuing to the junction with Daylight Pass Road. From Stovepipe Wells, drive 7 miles east on CA 190,

turn left toward Scotty's Castle, and turn right after a quick 0.7 mile. Continue about 7 miles to the angular junction with Beatty Cutoff Road.

Goldwell Open Air Museum (10)

Scattered about the base of the Bullfrog Hills is an eccentric collection of outdoor sculptures. It's a worthwhile diversion on the way to or from Rhyolite, and it's another area that benefits from eerie clouds and nighttime skies. Crafted by a group of prominent Belgian artists, these seven pieces include a life-sized, ghostly interpretation of Da Vinci's *Last Supper* painting, a 25-foot-high pink woman made of cinderblocks, a 24-foot-high steel prospector accompanied by a penguin, a blossoming tangle of gleaming chrome car parts, and an exquisitely carved winged woman reaching for the sun from high atop a wooden pillar. Limited interpretation is on hand, so visitors are encouraged to cultivate personal interactions with these curious works.

The museum's mission is to preserve and support artistic exploration in and of the Amargosa Desert—an evocative landscape along the eastern edge of Death Valley National Park. The museum provides ongoing maintenance

Ghosts at the Goldwell Open Air Museum

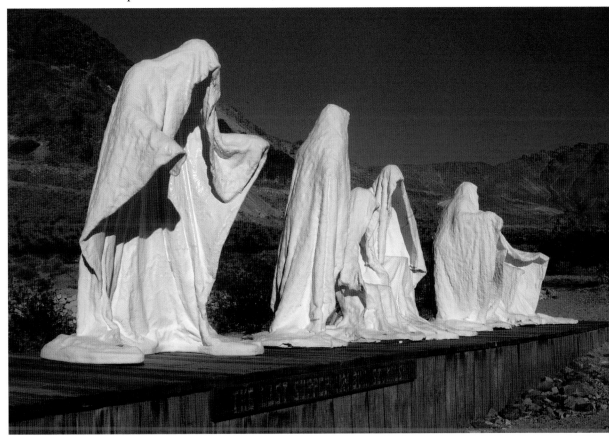

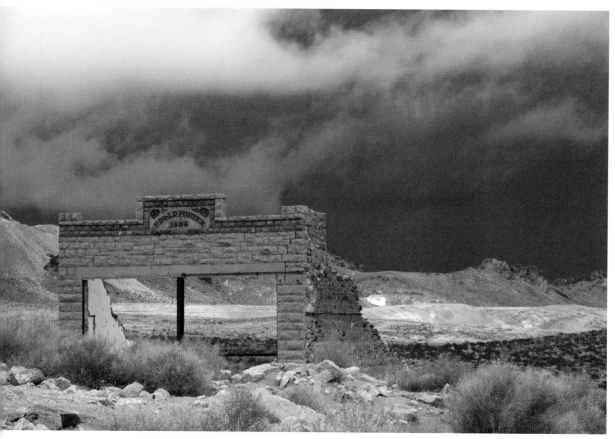

Rhyolite ghost town ruins

and conservation for the existing sculptures and develops educational and cultural programs to enhance the visitor's experience of the site. Artworks of the museum are private property and protected by copyright. While noncommercial photography is allowed at all times, commercial photography, film, and video recording require permission from the property owners.

Directions: The museum is located on Rhyolite Road, almost 1 mile north of NV 374. From Beatty's main intersection, take NV 374 west, continue about 3.7 miles, and turn right onto Rhyolite Road. Traveling from Stovepipe Wells, take CA 190 east to the Scotty's Castle Road, and turn left. Make a quick right onto

Daylight Pass Road, cross into Nevada, and turn left onto Rhyolite Road.

Rhyolite (11)

If you enjoy exploring ghost towns and abandoned-structure architecture, definitely set aside some time for trolling around in Rhyolite. Dubbed the "Queen City," this community was Death Valley's largest from 1905 to 1911. Boasting a heyday population of 5,000 to 10,000 people, Rhyolite supported 50 saloons, 18 stores, 19 lodging houses, a stock exchange, and an opera. Today's town site features a compelling collection of ruins, including a three-story bank building, a jail-

house, and a train depot. Another structure of interest is the enigmatic Bottle House, though its protective surroundings pose some photographic challenges.

It's easy to get lost in the charm of Rhyolite; these structures make terrific photo subjects—especially against a stormy skyline. Also consider that many scenes hold potential as black-and-white and sepia conversions. Nearly all the buildings are rich in weathered texture, several with period architectural details well intact. Ample space surrounds most structures, so a variety of views from intimate to territorial is possible. Graphic elements are plentiful as well, so experiment with compositions that engage windows and rafters. Because of its easy access and open skies, Rhyolite is popular with nighttime photographers. Position yourself low and in front of the buildings' frameworks to maximize celestial opportunities.

Directions: From the Goldwell Open Air Museum, continue north about 0.5 mile to Rhyolite's main corridor.

Keane Wonder Mine and Mill (12)

Gold mining operations at Keane Wonder Mine were fairly successful from 1903 to 1916 and again during the 1930s. Today mill ruins are still visible in the canyon, and the old tramway scales the western Funeral Mountains. Since the Keane Wonder site isn't a stellar magic-hour subject, chances are high that you'll visit the area during late-morning to early-afternoon light. Mining operations and weathering cultural sites frequently benefit from direct sunlight and blue skies by reinforcing the prospectors' hardships. The distressed surfaces yield plentiful textural studies and translate well to color, black-and-white, and sepia-tone studies.

Directions: From the Furnace Creek area, turn left onto CA 190. Travel 11 miles, and bear right at Beatty Cutoff Road. Travel about 5 miles, and make another right at the Keane Wonder Mine access road. The parking area is located at the end of a 2.8-mile graded gravel road.

Keane Wonder Mine relics

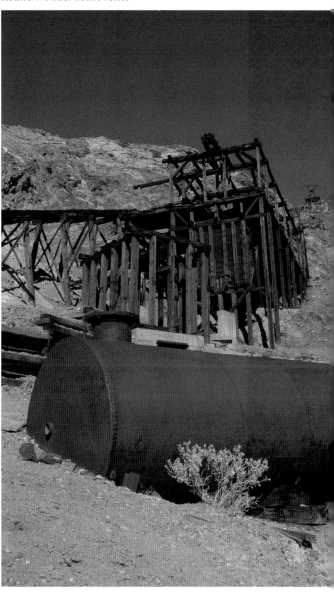

Date palms at Furnace Creek Ranch

Furnace Creek

SPRING ★ ★ ★ ★ SUMMER ★ FALL ★ ★ ★ WINTER ★ ★ ★

General Description: Furnace Creek is the commercial heartbeat of Death Valley. Higher-end lodging options, creature comforts, and even shade trees are found here. You'll also find the park's only full-service gas station, situated between the palm grove and the visitor center. It features 24-hour gas pumps (including diesel), tire repair, AAA towing, an ice machine, propane refills, and basic mechanical services.

Directions: Bordering the western side of CA 190, the Furnace Creek Ranch area is nearly impossible to miss. The Furnace Creek Inn, perched on a foothill, is located a bit east of the ranch operation.

Specifically: The Furnace Creek area can be a great place to recharge your batteries. In the heat of triple-digit temperatures, nothing beats grabbing a cold treat in the general store or a quick meal in the air-conditioned the 49'er Café. Browsing the bookstore of the **Death Valley Natural History Association (NHA)**, watching a park service film, or taking in the exhibits in the **Furnace Creek Visitor Center** are other fine ways to beat the midday heat. In addition, it's possible to check e-mail using the NHA's free wireless signal. You can also praise the plentiful non-native tamarisk trees located throughout the area. Their willowy branches generate welcome shade, and parking under them is often competitive. Unfortunately, though, tamarisks have a zealous thirst and

Where: The main lodging and commercial community of Death Valley National Park—"home base" for many park visitors

Noted For: Death Valley's main visitors center, various cultural history sites and artifacts, a colorful canyon, annual '49ers Encampment activities

Best Times: Spring, fall, winter

Exertion: Minimal to moderate

Peak Times: Spring (especially in March and April), even more so during prolific flower spreads; first two weeks of November during '49ers Encampment

Accessibility: All vehicles; many interpretive sites and exhibits have disability access

Parking: Dedicated lots for RV and passenger vehicles available at Furnace Creek Visitor Center, the general store, and dining buildings

Facilities: A general store/gift shop, gas station, post office, golf course, tennis courts, paved airstrip, Laundromat, and an ATM machine; swimming and showers available at Furnace Creek Ranch for a nominal fee; restrooms located at Furnace Creek Visitor Center, various campgrounds, and behind general store and dining buildings

Sleeps and Eats: Lodging available at Furnace Creek Inn & Ranch and three National Park Service campgrounds—Furnace Creek, Sunset, and Texas Spring; Furnace Creek Ranch offers three casual-dining options and a saloon, and fine dining is available at the inn's dining room

Sites Included: Borax Museum, Harmony Borax Works, Mustard Canyon, Furnace Creek Inn & Ranch, '49ers Encampment, Furnace Creek Golf Course Bird Observation Platform

negatively impact native plant and animal communities. As a result, the park service has scaled back the presence of this exotic species, limiting them as much as possible to the Furnace Creek and Stovepipe Wells communities.

Furnace Creek Ranch (13)

The grounds of Furnace Creek Ranch feature an assortment of cultural subjects, including a locomotive steam engine, a twenty-mule-team wagon, and palm trees. Most are worth exploring during midday or bright overcast lighting, and all are accessible via short walks from nearby parking and picnic areas. **Old Dinah** and the **twenty-mule-team wagon** are hard to miss, located at the entrance of Furnace Creek

Wagon detail at the Death Valley Borax Museum

Ranch. Though these subjects receive direct southern light, their shaded, northern surfaces present opportunities for weathered texture, sepia tone, and/or black-and-white studies. Softer overcast skies minimize harsh shadows and enable you to craft compositions featuring full subjects and greater color saturation.

Both **date and fan palms** border CA 190 between the Furnace Creek business core and the gas station. The trunks and fronds supply plenty of prospects for images anchored in pattern and repetition. Using wide-angle or ultra-wide focal lengths and high f-stops, look skyward to emphasize vanishing-point perspectives. The date grove and picnic areas are also good places to observe and photograph birds. Sparrows and grackles are quite common here, and though roadrunners frequent the area I have only seen them twice—both times in dreadful light. Ravens frequent the area, as well, and occasionally you'll observe them in the truly comical process of harvesting dates.

Directions: Furnace Creek Ranch is located about 0.7 mile west of the CA 190 Badwater Road junction.

Death Valley Borax Museum at Furnace Creek Ranch (14)

Periodically you'll encounter daytime periods with milky, overcast clouds. Such conditions can be an utter, and often futile, challenge to shoot expansive landscapes. Fortunately, Death Valley has some appealing alternatives on days like these. One of the most fruitful spots is the Borax Museum at Furnace Creek, where you can step into and around a myriad of relics from Death Valley's legendary borax bonanza. Bright, overcast light is highly desirable for reducing harsh shadows and emphasizing color saturation of peeling paint and oxidized surfaces.

The museum structure itself once served as a miners' boardinghouse in Twenty Mule Team Canyon, before its relocation to Furnace Creek. Indoors you'll find everything from geology samples to vintage media pieces documenting the area's mining history. Tight quarters and enclosed exhibits make it difficult to photograph inside the museum, but plenty of fun can be had out back. If you're at all fond of cultural history, the Borax Museum is a must-see!

Access the backyard by passing through the indoor exhibits or via the outdoor porch. Large pieces of mining machinery and historical exhibits are scattered about the area. There are also fine examples of borax-boom transportation, including colorful buggies, wagon beds, and locomotives. Many of these subjects are workable from multiple vantage points. Use short telephotos and normal focal lengths to garner straightforward compositions highlighting lines and geometric form. For intimate and abstract studies, try telephoto and macro lenses. Wide-angle lenses will enable broader compositions, though you'll have to work harder to avoid visual distractions like fences and power lines.

Directions: The Borax Museum is located on the western boundary of the Furnace Creek commercial corridor. Indoor artifacts generally can be viewed from 8 AM to 5 PM, though museum hours may vary seasonally. The backyard is accessible 24/7.

Furnace Creek Golf Course Bird Observation Platform (15)

At one time, access to the world's lowest golf course was limited to paying golfers. Thankfully, that all changed in 2007, with the addition of a first-rate bird-viewing platform. A nearby water hazard provides habitat for both resident

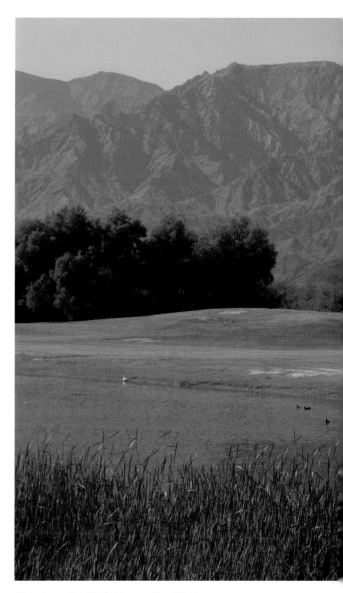

View from the Bird Observation Platform

and migratory species. Coots, mallards, and the occasional great blue heron are known to frequent the area, though seasonality and unusual weather patterns may invite unique exotics. It's also possible to spot coyotes stalking coots or even chasing golf balls. Regardless of who's hanging around, you'll need powerful

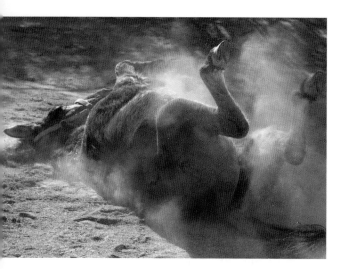

Mule rolling in the dust, '49ers Encampment

focal lengths to capture the action. Light is kindest here during early mornings and bright overcast periods. Even without powerful glass, this remains a sublime spot for bird-watching.

Directions: The bird-viewing platform is located about 0.5 mile off CA 190. Instead of bearing right into the Furnace Creek Visitor Center parking area, continue straight onto the Death Valley Airport Road. The platform is visible to the left and accessible by a short path. Limited parking is available alongside the airport road. If you're already parked at the visitors center, another option is to cross through the foliage divider in the lot's southwest corner, and walk about 0.3 mile to the platform area.

'49ers Encampment (16)

Each November a passionate nonprofit group, known as the Death Valley '49ers, celebrates the spirit of California-bound pioneers who persevered during the winter of 1849–'50. These volunteers seek to expand public awareness of Death Valley and foster appreciation of the area as a rare desert environment with unique natural and cultural histories.

Annual encampment activities typically span a 7-to-10-day window wrapping around the first two weekends in November. Such principal events as the Pioneer Costume Contest and Wagon Train Arrival unfold in the Furnace Creek area during the last five days of the encampment, though some (a wheelbarrow race and an art show) take place at Stovepipe Wells. Other entertaining events include a pampered pet contest, a parade, and a fiddlin' competition. To obtain a full encampment schedule, you'll need to become an official '49ers member. Nominal membership dues purchase the official program and an event access badge. Membership fees are tax deductible and contribute to a scholarship endowment fund for children living in Death Valley.

Visitation traffic during a '49ers Encampment compares to a spring with prolific flower spreads: BUSY! I'd advise securing lodging accommodations *before* making a spontaneous trip to Death Valley at that time of year. Serenity is likely to be in short supply, as well, though the cast of characters and lively happenings can't be beat for photo opportunities! Western wear and cowboy attitude presides, and live music plays nightly. Plus, newly inducted '49ers are welcome to join in the fun by participating in gold panning, horseshoe throwing, and the Coyote Howl (an open-mike night).

Information: To preregister for an upcoming Encampment or obtain additional information, visit the '49ers website at www.deathvalley49ers.org.

Furnace Creek Inn (17)

The elegant Furnace Creek Inn, a four-diamond resort constructed in 1927, overlooks the Panamint Range and Death Valley salt pan. Fortunately you don't have to be a registered guest to photograph the grounds. Cascading palm trees shelter a tranquil sanctuary of lily

pad pools and meandering streams. Without question this is a beautiful setting, though photographing it often presents some creative dilemmas—namely, a mix of bright light and heavy shadows. Early mornings and late evenings are apt to provide nice lighting, but that will prevent you from shooting a sweeping landscape subject. Should you make that trade, choose sunrise and early mornings to shoot the garden area and afternoons and evening twilight for wider views of the inn against the Funeral Mountains. Better yet, visit the inn grounds on cloudy or bright-overcast days, when softer light lends itself to more balanced compositions.

Directions: The Furnace Creek Inn is perched above the junction of CA 190 and Badwater Road. Park alongside the stone wall to the east of the inn, and then locate the tunnel to enter the garden or the elevator to access the inn proper.

Harmony Borax Works (18)

From the parking area, follow the short footpath to study remnants of Death Valley's borax boom. This site features many components of the Harmony plant's mining history, including transportation, machinery, piping, and building facades. Thanks to more than 120 years of weathering and oxidation, these surfaces are rife with texture studies. Compositions based on lines and geometric shapes are equally plentiful. Harmony Borax Works is a great spot to hit on bright-overcast days. Nice shots are also possible here in early mornings or late afternoons. You might also consider stopping here after shooting the sunrise at Salt Creek. It's probably best to avoid harsh midday light

Twenty-mule-team wagon

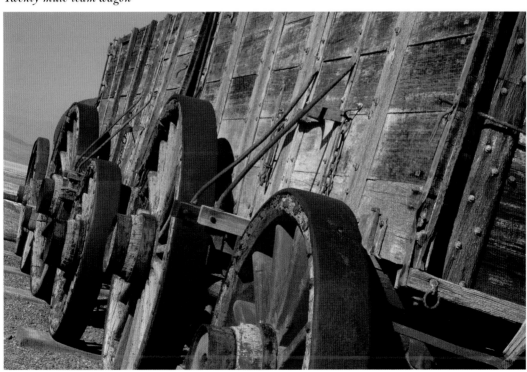

Mustard Canyon wall detail

since it washes out color and generates deep shadows—but such conditions may inspire opportunities for high-contrast sepia tone or black-and-white imagery. Your biggest challenge will be photographing unobstructed views of the wagons. Lines of protective fencing will likely restrict you to textural studies and tighter compositions. Simplify your scenes by using normal to shorter telephoto lenses

Directions: Leaving the Furnace Creek Visitor Center, turn left onto westbound CA 190. Look for the Harmony Borax turnoff on your left in about 2 miles.

Mustard Canyon (19)

This one-way route courses through ochre-colored foothills composed of salt and oxidizing iron. In fact, you can sometimes "hear" the dehydrogenation process in these creaking canyon walls! The dirt roadway is typically in good shape and easily negotiated by passenger cars. Though not a premier Death Valley photo site, Mustard Canyon is chock-full of nooks and crannies for discovering abstract imagery. You'll be able to accentuate these peculiar shapes and patterns using normal focal lengths and shorter telephoto lenses. Late-afternoon light is most complimentary on this yellowish brown palette, especially when incorporating an eastern blue sky.

Directions: Enter the Mustard Canyon Road from the north side of the Harmony Borax Works parking area. The predominantly flat route meanders about 1.5 miles before joining CA 190.

Badwater Road

General Description: Badwater Road is the gateway to Death Valley's lowest points and captivating canyons. Another popular destination is Artist's Drive, a scenic stretch winding through a series of striking badlands and vivid geology. Canyon trails negotiating the Black Mountains originate here, as well.

Directions: Badwater Road (a.k.a CA 178) turns south from CA 190 just west of Furnace Creek Inn. It hugs the salt pan, continuing southward to the Ashford Mill interpretive site. Beyond the mill the road wraps east, coursing through Jubilee and Salsberry Passes before joining CA 127 just north of Shoshone.

Specifically: Badwater Road features a rich concentration of Death Valley's top-rated photo spots. While the National Park Service has developed the geological gems along this route into interpretive sites, that shouldn't prevent you from stopping at other points for personal exploration. When something catches your eye, get out and scout around.

Golden Canyon (20)

There's no mistaking how these flaxen narrows received their name. While the palette of buttery hues bodes well for color photographers, they're also a favorite of black-and-white shooters. Like a diary of geological handiwork, Golden Canyon is the cumulative effort of flash floods, uplifting faults, and arid climate. Despite appearing silent and barren, this terrain continues to evolve. Upon entering the canyon's mouth, you might notice stray pieces of asphalt. This debris is the result of a four-day storm in February 1976 that wiped out a paved road into Golden Canyon.

Where: Below-sea-level terrain along the salt basin's eastern border and the western foothills of the Black Mountains

Noted For: Lowest elevations and hottest temperatures in the western hemisphere; canyon hikes, geology, vibrant foothills, expansive horizons, cultural-history sites

Best Times: Early spring, late fall, winter

Exertion: Minimal to challenging

Peak Times: Early to midspring—especially during prolific flower years!

Accessibility: Passenger cars to 4WDs with high clearance, depending on the road; restrictions on vehicle length apply on some roads (take seriously where noted any recommendations on vehicle types)

Facilities: Restrooms at Golden Canyon, Badwater, Natural Bridge, Ashford Mill

Parking: Dedicated paved lots at Golden Canyon, Artist's Palette, Badwater; gravel lots at Devil's Golf Course, Natural Bridge, Ashford Mill

Sleeps and Eats: Closest park lodging options are at Furnace Creek Inn & Ranch, and established National Park Service camping sites are available at Furnace Creek, Sunset, and Texas Spring; the Furnace Creek area offers three dining options and a bar

Sites Included: Golden Canyon, Devil's Golf Course, Artist's Drive, Artist's Palette, Natural Bridge, Badwater, Ashford Mill

Leftover pavement still serves as an informal stairway, though it quickly surrenders to a channel of crumbled mudstone and loose rock. The moderate pathway and mild elevation gain (300 feet) advance along the canyon's base. It's a 2-mile round-trip along the sometimes rocky and uneven surface. In addition to photo gear,

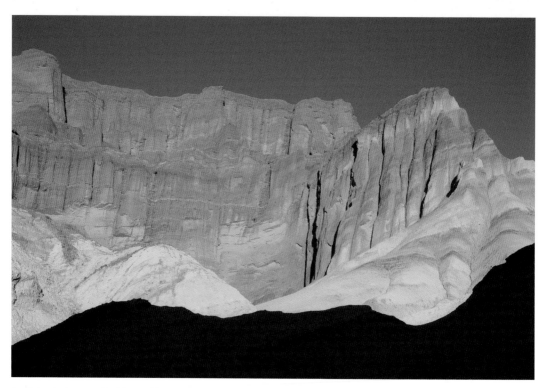

Red Cathedral at Golden Canyon

wear sturdy shoes and pack plenty of water to explore the canyon's meandering folds. Another handy item for this self-guided interpretive trail is the excellent pamphlet that's usually available at the trailhead for a nominal fee.

Golden Canyon is a great location to create images using negative space. Utilize the gullies and shadows to anchor monochromatic compositions. Late spring and early fall typically provide the best light. During these seasons, the sun's position graces the narrows with additional radiance while preserving surface texture within the canyon's interior. Photograph in early to late afternoons to capture luminous canyon walls.

If you desire richer color palettes, you might find the nearby auburn cliffs of **Red Cathedral** or the back side of **Manly Beacon** more appealing subjects. Both formations receive illu-

mination just before the sun dips below the Panamint Range. Manly Beacon also looks great against a twilight sky, so you may want to shoot Red Cathedral first while it's still in direct light. For compositions involving either subject, you'll need to use graduated ND filters or capture multiple digital images to account for the lighting difference between the higher elevations and the canyon's walls and floor. To score either of these images, hike to the back of Golden Canyon until you reach trail markers indicating route options. Interestingly enough, the marker sends you left for views of Red Cathedral while the trail guide sends you right. Personally I like the views attained via the left-hand route. As for Manly Beacon, you'll need to head right.

Golden Canyon's convenience to nearby lodging options makes it a wonderful spot to

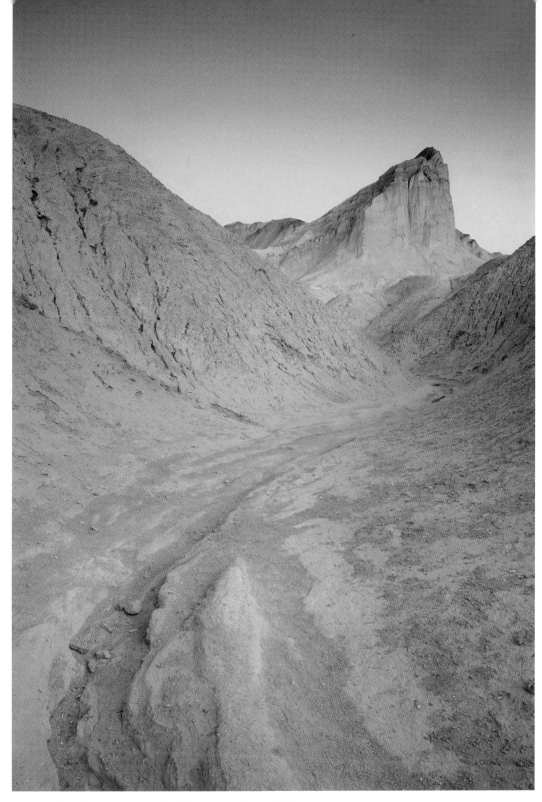

Western face of Manly Beacon (Golden Canyon) at twilight

experiment with night photography. Once twilight photo ops have passed, you can explore the walls for interesting shapes and emerging shadows. Position your camera northbound to capitalize on the arcing star-trails pattern.

Directions: From Furnace Creek, turn right onto CA 190, and continue to the Badwater Road junction. Turn right, and drive 2 miles to the Golden Canyon turnoff and parking lot on your left.

Mushroom Rock (21)

At one time, Mushroom Rock was a designated park attraction with a sign and a parking lot. The signage and parking area are no more, but even with humbled status, this charismatic chunk of volcanic rock is still worth exploring. Just park your vehicle across the road, and amble up the hillside. Wider focal lengths work well here, especially if you're interested in illustrating the surrounding topography. Accentuate the formation's contour by shooting at or below its base. Being low to the ground will also minimize the presence of pavement if your compositions face Badwater Road. Cinders cover the ground surface, so consider bringing along some protection for your hands and knees. Photographing in late morning will enable you to incorporate northwest skies and the Panamint Range. Views to the southeast will be better in the afternoon. Light may also be good into sunset and early-evening twilight, though I wouldn't dedicate sunset time here unless you've already had success at Devil's Golf Course or Artist's Drive. Better yet, squeeze in a quick shoot at Mushroom Rock en route to other Badwater Road attractions.

Mushroom Rock

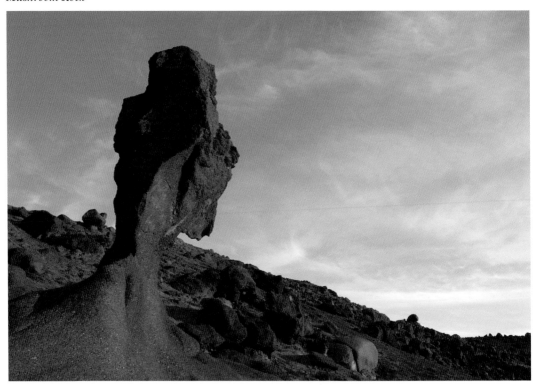

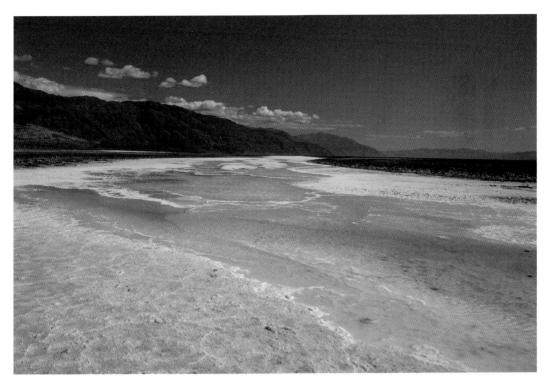

Pooled water at the Devil's Speedway

Directions: You'll find Mushroom Rock about 5.8 miles south of the CA 190/Badwater Road junction. The formation is to your left, perched on a rock-strewn embankment.

West Side Road (22)

For a full-circle appreciation of the Badwater salt pan, consider driving the length of West Side Road. This 40-mile dirt surface stretches along the salt pan's western boundary. It's generally safe for passenger cars, though it can be bumpy and rutted in spots. Conditions are usually dusty, and safe travel is slow going—so budget several hours for ample driving and exploration time.

Heading west off Badwater Road, the first photogenic stop is **Devil's Speedway (23)**, about 2.5 to 3 miles in. Here you're likely to find engaging terrain on either side of the road.

During sunrise and early mornings, the north side is preferable for unobstructed horizon views. In the afternoon, southern views feature a Black Mountains backdrop and an alternate take on the salt basin. After a rare plentiful rainfall, standing water creates almost beachlike scenes. Water or not, you should be able to utilize the area's graphic elements. Look for C-shaped water lines and/or geological handiwork to suggest depth.

Continuing south, another area worth wandering about is **Eagle Borax Works (24)**. Remnants of this mining operation are about 2 miles beyond Hanaupah Canyon Road. I doubt that you'll plan a dedicated magic-hour shoot here, but certainly explore the area for cultural artifacts if you've come this far. Abundant greenery flourishes, courtesy of nearby Eagle Borax Spring, and you can often

use the foliage to frame landscape scenes. Eagle Borax Works also marks the final portion of below-sea-level terrain. From here, the elevation rises gradually as it transitions to the Amargosa River dry wash on your left.

Past this point, the topography isn't all that interesting, especially in broad daylight. If it's midafternoon, you can continue south for late-afternoon or evening sessions at **Ashford Mill** (see site 33). If you return north at about the same time, there's a good chance you'll rejoin Badwater Road with ample time for late-afternoon or sunset shooting at **Golden Canyon** (see site 20), **Devil's Golf Course** (site 27), or **Artist's Drive** (site 25). You might also factor seasonality, cloud formations, and lighting before determining your return course.

Pro Tips: Having driven West Side Road a number of times, I've developed a personal bias for the Devil's Speedway area. It's just a short drive from Badwater Road, and the surrounding geology lends itself to a variety of interpretations, from wide-angle to macro. Plus, I'd suggest saving precious time and gas for hitting parts of Death Valley with greater image potential.

Cautions: In addition to being the salt pan's secondary north-south throughway, West Side Road is also the primary access route to Death Valley's backcountry canyons. Exploring these routes requires advance preparation, significant time and fuel resources, a healthy high-clearance 4WD vehicle, and accomplished driving skills. Should you wish to visit these remote sites, definitely consult one of the backcountry guidebooks recommended by the Death Valley Natural History Association.

Directions: From the CA 190 junction, take Badwater Road heading south, and continue 6 miles to the southbound spur of West Side Road.

Artist's Drive (25) 🎞️↩

Artist's Drive is a late-afternoon and early-evening destination. This narrow, one-way road is possibly the most scenic route in the park. Its beauty unfolds with each twist and plunge as the 9 miles of pavement slivers through the western foothills of the Black Mountains.

The road surface is narrow and parking is limited to shoulder areas, so you'll find great value in making an initial scouting trip. A single pass without stops takes about 30 minutes. Set aside enough time to explore and identify possible areas of interest as well as convenient pull-offs. Sometimes the closest parking spot is one that puts a desired photo site behind you.

One worthwhile spot lies at the first pull-off you encounter. Scale the rise just beyond the shoulder, and wander out into the open areas. These slopes are some of my favorites in the entire park. Though I'm not aware of any official names for this area, I think of the mounds off to the southeast as the "Hot Fudge Sundae Hills." Whatever section of these sedimentary hills strikes your fancy, experiment with different creative motifs by working both wide and isolated views. As the light shifts, scope out interesting shadows, texture, and illuminated folds.

Watch for the higher terrain just before the turnoff for **Artist's Palette** (see site 26). These vantage points offer greater opportunity to incorporate the sky. Being positioned a bit higher than the palette itself, you are poised to observe and utilize changing light conditions. The downward angle also sets up the possibility of using drainage patterns in the wash as leading lines. During a damper spring, you might even find flowers to create pleasant foreground interest.

Pro Tips: Sunrises really aren't worth the trouble here. An absence of appealing silhouettes and limited western views squanders any nice light in the eastern horizon. Instead decide on

which of the striated hillsides appeals to you, and return about 90 minutes prior to sunset to set up your gear for late-afternoon and sunset light.

Cautions: Observe the posted speed limit. At times the road feels like a roller coaster, and many of the turns are tight and blind, especially past Artist's Palette.

Directions: From Furnace Creek, turn right, and travel CA 190 to the Badwater Road junction. Turn right again, and continue about 8.5 miles to the Artist's Drive entrance on your left. Note that this route is limited to vehicles of 25 feet or less.

Artist's Palette (26) 🌺🌿

Oxidizing mineral deposits produce the pastel hues of this interpretative site, which is the centerpiece and premier attraction of Artist's Drive. Iron salts form the reds, pinks, and yellows while mica and manganese create the green and purple pigments. The colors reach their peak intensity from late afternoon to shortly before sunset. Since the park service promotes this window as the preferred time to hit Artist's Drive and Artist's Palette, it's unlikely you'll be alone here—especially during spring and peak flower years.

Many paths descend from the parking lot into a wash area at the base of this colorful hillside, so it's routine for someone to unknowingly wander into your frame. If you're lucky, they'll wander out just as quickly. If not, you can always shoot the bugger, anyway—having people in the landscape does create a sense of scale. Another option is to mildly adjust your shot so that you can revert back to the original composition if the person moves. And then there's the prospect of moving locations altogether.

The colors of Artist's Palette

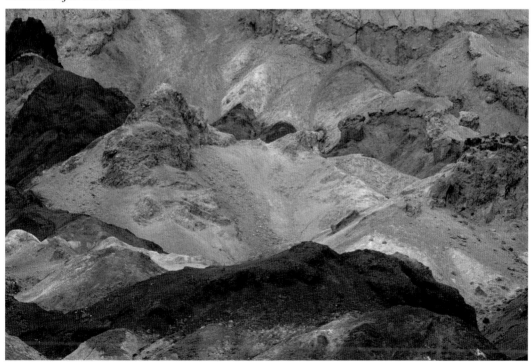

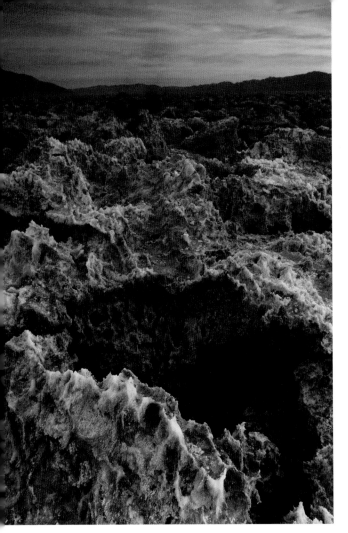

Salt crystals make up the Devil's Golf Course

other spots along along Artist's Drive more appealing, by all means try your luck there. Though I've never experienced magnificent conditions at the palette itself, I have at other locations along Artist's Drive.

Directions: The parking area for Artist's Palette about 3.8 miles in on Artist's Drive.

Devil's Golf Course (27)

Though this serrated surface would surely be a golfer's worst nightmare, it scores a hole-in-one as a photographer's creative playground. These gnarled salt crystals are the residue of Death Valley's last significant lake, which evaporated 2,000 years ago. Their otherworldly appearance can spawn creativity at nearly any time of day, though magic hours will generally treat you best here. Definitely set aside time to survey the area before unveiling all your gear. Instead, take just a camera and a single lens, preferably one in the wide- or ultra-wide-angle range. To fully realize the possibilities here, remember to crouch down and consider multiple angles and orientations.

Initial views are possible from the parking area and along the approach route, but it's worth the effort to tread deeper into this peculiar geological formation. Foot traffic has trampled the spires closest to the parking area, so venture out a bit to discover shapes that are increasingly jagged and more appealing. Wide-angle and normal-range lenses are wonderful tools for personifying this alien landscape. Telephotos will channel attention toward eerie patterns, while macros assist in composing tighter details and abstract images. Post-processing your shots as black-and-white is yet another alternative—the incredible texture and negative space of this terrain renders beautifully in monotone depiction.

Devil's Golf Course holds great potential for late-afternoon and sunset photography. If

In the spring, storm clouds sometimes develop above the palette. Such skies can enrich daytime compositions that would otherwise be less interesting. If you're scouting the route during these conditions, try using wide-angle lenses to convey the expansive qualities of both the atmosphere and landscape. For calling attention to geological patterns, glowing afternoon hillsides, and abstract elements, a short- to moderate-range telephoto should do the trick.

It's worth noting that light is not always cooperative at Artist's Palette. Should you find

nimble clouds abound, consider yourself blessed for they can pack extra promise. Anticipate the Black Mountain badlands to glow as the sun dips toward and behind the Panamint Range. At the same time, maintain an awareness of what's happening in both the northern and southern horizons to benefit from any electric moments that may present themselves. On spectacular evenings, you'll be rewarded with abundant splashes of pink and orange in the southern sky.

You can bag rewarding sunrises here, too. Once again hope for clouds, and arrive early enough to catch morning twilight. Study the Panamint Range and the northern and southern horizons for possible compositions, and be ready to shoot when the light show unfolds. After periods of generous rainfall, water pools among the spires, creating fantastic reflection opportunities.

Cautions: Wear sturdy boots, and toddle carefully along the crystallized spires. These structures are sturdier and sharper than they appear. For that reason, kneepads, fingerless gloves, and protective padding may come in handy should you decide to work low to the ground with macro or wide-angle lenses to emphasize foreground details. Camera gear can take a beating on this surface, too, so utilize lens caps and hoods to preserve your glass.

Directions: You'll find the signed turnoff to Devil's Golf Course 13 miles south of the Furnace Creek Visitor Center on Badwater Road. The 2-mile gravel access road is usually in good shape and easily navigated by passenger cars, though it is subject to closure after flash floods or periods of plentiful rainfall. Should you encounter standing water in this area, consider driving around it or carefully through the shallowest part. The salinity concentration will be high, and damage to your vehicle's underside could be pricey.

Natural Bridge (28)

Death Valley is not known for arches or hoodoos, but one possible exception is Natural Bridge, a 50-foot-high limestone bridge spanning parallel canyon walls. Though not an especially strong subject, it's certainly worth exploring. Consider visiting this site when you're in the Badwater neighborhood, either in the afternoon before sunset or in the late morning after sunrise. Given the right mix of cloud and lighting conditions, Natural Bridge or the surrounding canyon walls may yield some interesting shots. Wide-angle or ultra-wide-angle focal-lengths are essential to craft compositions that include the bridge and significant portions of the surrounding canyon.

Lighting conditions will be challenging here in the early morning as the bridge formation will be backlit. Afternoons may be easier to manipulate in-camera because the sun will be coming from the west. Still, shadowing and broad lighting differences are strong possibilities. Blending multiple captures in-camera or via digital darkroom techniques is probably your best bet for capturing the scene as your eyes view it. Nighttime shoots are fun here, too. A full or gibbous moon will produce conditions for deep shadows, illuminated rock faces, and shorter exposures. Evenings with a crescent or new moon offer opportunities to experiment with flashlight painting and longer exposures and star trails.

You'll find the start of the 1-mile trail behind an interpretive sign at the east side of the parking area. Trekking along the canyon's dry wash is similar to walking on a sand beach. Add to that the fact that it's a mild uphill incline toward the bridge, so heading in will be a bit slower than coming out. From the trailhead, allow roughly 10 minutes to reach the bridge.

Directions: From the Furnace Creek Visitor Center, turn right onto eastbound CA 190.

Take another right onto Badwater Road (CA 178), and travel 13.2 miles south. The gravel access road will be on your left. While the initial approach is in fairly good shape, watch for rough patches of rutted asphalt just before the parking area.

Badwater (29)

Badwater might be the most highly visited geological attraction in the park. It would seem just about everyone makes a stop here regardless of their trip's length. Without question, investigating the lowest point in the Western Hemisphere, and viewing permanent spring-fed pools are magnetic draws. For starters, it's a chance to observe water in one of the driest places on the planet. Additionally, it presents photographers an opportunity to create images that incorporate mirrored reflections of compelling skies and angular hillsides. Expect continual visitors from about 90 minutes after sunrise through late afternoon. If there's a decent wildflower spread, count on even more bustling. During sunrise shoots, the Badwater boardwalk can be a very competitive spot. Usually it's just serious photographers until the casual shooters and sightseers have enjoyed their breakfast.

The excessive foot traffic around the pools was destroying a delicate ecosystem and endangering endemic life forms such as the Badwater snail, so in response to this habitat damage, the National Park Service redesigned the interpretive area. Since the walkway's unveiling in 2004, photo ops incorporating reflections have become considerably more challenging because the ramp and boardwalk can obscure initial impressions of this area. But thanks to the protective viewing platform, aquatic life forms have rebounded. It's now possible to observe tourists admiring organisms swimming about the pools, and occasionally you'll notice sandpipers scouting for a saltwater snack.

Early-morning shoots present some of the best opportunities. Sunrise caters to wide-angle compositions and is more apt to feature vibrant color palettes and cloud formations. Plan to arrive early and act promptly as such windows of opportunity come and go quickly. Once color subsides in the northern horizon, you may want to scout out new compositions that exclude the sky entirely by switching to a lens of normal or short-telephoto focal length. Badwater is also a fine late-day-through-sunset spot. Afternoon lighting illuminates the Black Mountains, and the reflected attributes and surrounding environment have a distinctly different look. Tranquil early-morning and later- afternoon winds translate to optimum conditions for depicting reflections. For wide-angle compositions at either time of day, you'll need to collect multiple captures or use graduated ND filters (of two or three stops) to balance the lighting differences between sky and foreground.

While the spring-fed pools at Badwater are the marquee attraction, the boardwalk also affords effortless access to Badwater Basin. On mornings when uncooperative winds transform reflections to ripples, you'll definitely want to search out of the renowned **salt pan polygons (30)**. Evaporation has fashioned these saline tiles into a surface that stretches north and south about as far as your eye can see. The farther out you venture, the less traveled and more interesting the shapes become. In some places you'll find the surface takes on the appearance of a meticulously laid stone terrace while in others, it appears fractured and upended.

With commanding views of the northern and southern horizons, the salt pan is an outstanding spot at both sunrise and sunset. Anchor your compositions with strong contour and geometric patterns to achieve striking imagery. Even a mild shift of positioning can maximize graphic impact. Additionally, using

a low perspective, wide-angle lens, and lead-ing lines will lure your viewers into a scene. When conditions warrant, plan to shoot from daybreak until early morning or late afternoon until twilight.

Morning is my favorite time to shoot the salt pan. Temperatures are most comfortable this time of day, and pristine predawn skies are prone to rich color saturation. Position your-self to the north or northwest to capture muted pinks and blues generated by earth shadow. As you might expect, compositional options will depend on atmospheric conditions and the sun's seasonal position. Any assembly of clouds at sunrise is an added bonus and a prime con-dition for yielding dramatic light. To benefit from any opportunities that present them-selves, maintain awareness of your surround-ings, and be ready to reposition your gear if necessary. As the sun climbs, the soft pastel palette will be replaced by bold segments of crystallized crust and dominant shadows be-fore flattening out and losing detail. Afternoon shoots can be similarly rewarding, though Panamint Range backlighting and atmospheric haze can dilute the color quality.

Badwater and the salt pan are definitely ar-eas I would revisit more than once, especially if you are staying several days or return on future trips. The creative possibilities are numerous, and conceiving imagery in both color and black-and-white is almost effortless. Since the light-ing and ambiance will vary from visit to visit, it's doubtful you'll be able to fully explore the area with different focal lengths and film types in just one visit. Still, toting a full range of lenses can't hurt, so pack as much as you can comfortably carry, including grads, extra cards or film, backup batteries, and a polarizer.

Cautions: The salinity at Badwater can quickly penetrate the surface of your skin, clothing, and—most importantly—your camera gear. You

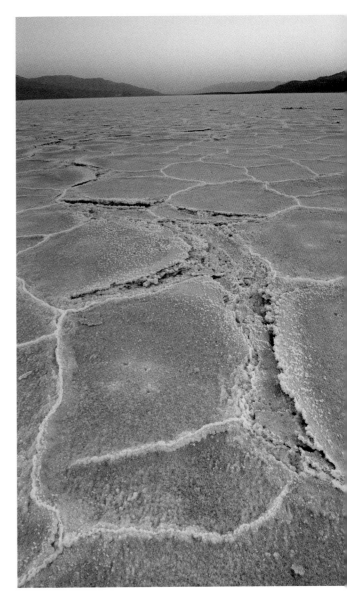

Salt pan polygons

should definitely wipe down your shoes and equipment after shooting to prevent corrosion.

Seasonal Safety: Summertime is generally NOT the season to embark on a lengthy hike in this area. From mid-May to early August you can be guaranteed a sweat session. Touching

anything metal during this time won't be pleasant, either. Cloudless skies and torrid ground temperatures should convince you to avoid summer shoots in and around the salt pan. But if a summer shoot at Badwater is your only option, plan a sunrise session, when the day's temperatures are lowest.

The "devil's fortune cookies" at Badwater Basin

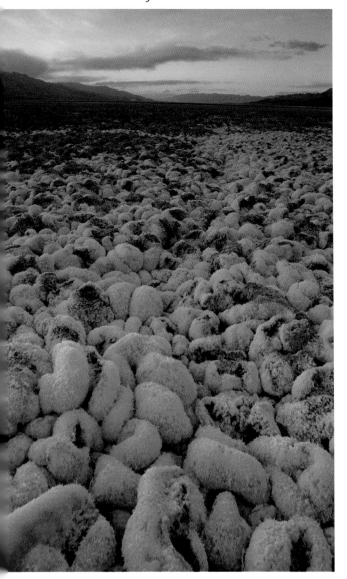

Directions: From the Furnace Creek Visitor Center, turn right onto CA 190, and make another right at Badwater Road (CA 178). Travel 18 miles south to the parking area overlooking the boardwalk. Access the interpretive site via a short ramped walkway. If your intention is to photograph the salt pan, allow an additional 30 to 45 minutes for transit and scouting time.

Badwater Basin—South of Badwater (31)

In *Desert Solitaire,* Edward Abbey expressed great frustration about people who experience the desert only at dedicated turnouts or through their car windows. Sadly, his observation continues to hold true since most Death Valley visitors fail to explore the salt pan beyond the Badwater interpretive site. What a shame! The Badwater Basin is not only quintessential Death Valley, it can inspire prolific photo ops at almost any time of year—except possibly high summer. Varying light and weather patterns dole out so many looks, it's possible to shoot the salt pan over and over, crafting unique imagery each time.

For a distinctive take on the salt pan, consider exploring lesser-traveled parts of this surreal expanse. Though not as heavily documented as Badwater, the basin's remaining surface is no less dynamic, given the right conditions. Keep in mind that topography varies considerably, and any surface that appears consistently smooth and alabaster from the road could be teeming with creative potential. Purely by accident I've discovered mesmerizing drainage lines and dehydrated salt formations resembling fortune cookies. Of course these features never appeared on an official map—and being subject to constant change, they now exist only in my image files. Not to worry, though; Mother Nature's handiwork has undoubtedly replaced them with new, equally

exciting designs for your very own Death Valley time capsule!

South of the Badwater parking area, the pavement makes some abrupt curves. Observe the speed limit and other safety designations while taking visual surveys of the salt pan. Interesting subjects are plentiful for the next several miles. Identify an alluring spot or select one at random, park safely on the shoulder, and venture out to explore. The distance and quality of terrain between pavement and the actual salt pan vary considerably from a flat stroll to navigating rocky embankments. After periods of ample precipitation, some spots can be spongy and even sticky enough to steal shoes. Watch for clues by analyzing the depth and traffic of recent footprints. In the anomalous weather patterns from August 2004 through spring 2005, a present-day rendition of Lake Manly reappeared, immersing Death Valley's lowest elevations. Water deep enough for kayaking persisted in the Badwater Basin for several months. Eventually the dehydration process scaled back the moisture, unveiling a pristine salt pan with new and uncharted photo ops.

Badwater Basin is definitely a muse for spacious compositions, offering tremendous views of both northern and southern horizons. All the previously mentioned concepts for salt pan photography will transfer to your personally discovered site, so plan a sunrise or sunset shoot for premium lighting opportunities. Be sure to note the nearest mileage marker so that you can return during favorable lighting conditions or on future trips. If you're shooting digital, take a reference shot as a reminder of the area.

Pro Tips: The salt pan washes out in direct sunlight. If you're scouting at midday, recall terrain you've already experienced at Badwater during magic-hour light and invoke your imagination to consider what an area might look like at sunrise or sunset. If you're unsure and have the time, come back anyway and see what unfolds.

Directions: The best salt pan access along Badwater Road (CA 178) extends from CA 190 at the base of Furnace Creek Inn to just north of Mormon Point.

Mormon Point (32) 🌸📷

Roughly halfway between Badwater and Ashford Mill, a predominant segment of alluvial fan extends to the road surface. This sloping stretch, known as Mormon Point, is an elevated vantage point to photograph northern views of Death Valley. Explore the Mormon Point area after finishing a sunrise shoot at Badwater or Ashford Mill. By late morning the sun should be behind you, and scrambling up one of the many crests will obtain the broadest views. Pack a lens of normal or moderate telephoto length plus a polarizer to compose images of the salt pan and Panamint Range. If you're feeling adventurous, drive the 0.2-mile dirt spur to an informal parking area. From there you're free to explore two drainage culverts. Willow Creek is on your left, and I've often found shaded flowers here during a damper spring.

Directions: From the Badwater parking area, turn right, and continue 14.4 miles south to Mormon Point. Look for the limited parking pullouts along Badwater Road, or park along the entrance of the dirt spur located on the north side of Mormon Point.

Ashford Mill (33) 🌸📷

The ruins of Ashford Mill may not seem like much at first glance—especially at midday. However, they are excellent supporting players for sunrise, sunset, and nighttime compositions. The rolling terrain has a reputation for

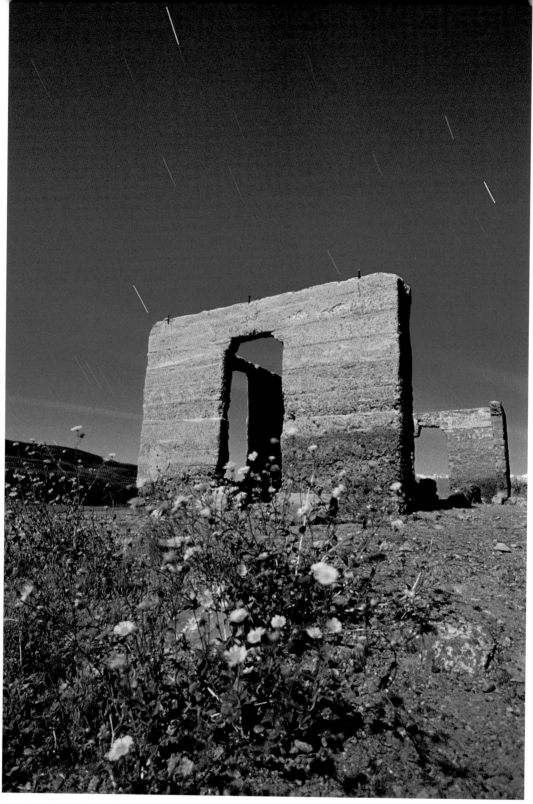

Star trails over the Ashford Mill ruins

abundant wildflower spreads, even in light-to-moderate wildflower years. And during a spring with exceptional blooms, this area is often stunning! Looking west from the ruins, it's hard to miss the protruding mass of **Shoreline Butte**. This striated basalt formation displays lingering evidence of ancient Lake Manly's receding shoreline. In springtime the butte often appears mossy green—though be warned: the color concentration often subsides the closer you get.

You'll enjoy the best photo ops during early morning and late afternoon. Though not typically noted as a sunrise spot, Ashford Mill provides plenty of options, with and without the architectural remnants. On clear mornings you'll likely encounter wonderful Earth shadow above the Panamint Range. The pastel hues of blue and pink look especially stellar embracing a snowcapped Telescope Peak. Late in the day you may wish to ignore the ruins altogether, focusing instead on the afternoon light as it graces Ashford Peak and the alluvial fans of the Black Mountains. Light can shift quickly, so be prepared to adapt by readying your graduated ND filters or multiplexing digital exposures.

A wide variety of looks are possible at Ashford Mill, so bring both telephoto and wide-angle lenses. In the spring, pack your diffusers and close-up gear, too. The predominant flower spread might appear yellow, though ground level exploration should reveal additional colors. In addition to photo gear, remember to pack ample patience to craft strong compositions and wait out the breezes. Should the wind deter sharp macro work, consider using the ruins to anchor territorial compositions.

Pro Tips: Night shoots at Ashford Mill can also be rewarding. Photographing the ruins by the light of a full or nearly full moon produces images resembling midday—only eerier on account of the stars.

Diversions: Another area worthy of exploration in a banner flower year is the **Ashford Canyon Road (34)**. This coarse dirt side road just opposite the Ashford Mill turnoff continues for 3 miles to the mouth of Ashford Canyon and Ashford Mine trailhead. But you shouldn't have to travel that far to locate photogenic blossoms. Visit the canyon early and late in the day for shady patches and reduced winds—both desirable factors for macro work. The road can be rough and/or sandy in places, so both 4WD and high clearance are recommended.

Directions: From the Badwater parking area, turn right and continue 26.7 miles south. The turnoff for Ashford Mill will be on your right.

Jubilee Pass (35) 📷🌿

In springtime this area can produce some wonderful wildflower displays. Of course, this depends on rainfall during winter and early spring being average or better. Unless you're flexible enough to base your visit on location conditions, some luck in the timing department is always a good thing. To maximize your flower karma, schedule your visit to Jubilee Pass sometime in March or April. If you've seen flowers around the mill ruins, chances are very high that something similar will be happening here. Since this spot is close to Ashford Mill, it's worth the short drive to see what flora might be blooming. Common sightings include golden evening primrose, notch-leaf phacelia, Arizona lupine, lesser mojavea, Bigelow's monkeyflower, and gravel ghost.

Directions: Jubilee Pass is located about 8 miles south of Ashford Mill. From the interpretive site, turn right onto Badwater Road (CA 178), and continue as the route elbows left, climbing in elevation. Flowers are possible anywhere along this 1-mile stretch, so be on the lookout for patches of color.

CA 190 East and South of the Furnace Creek Inn

General Description: This segment of the Amargosa Range is a collection of geological nooks and crannies that possesses some of the park's most colorful textures and towering views. In addition, the increased elevation provides cooler temperatures than those of the valley floor, especially in the morning and during windy conditions.

Directions: Heading east from the Furnace Creek Inn, CA 190 hugs the higher-elevation side of the Amargosa subset range known as the Black Mountains. Once past the Dante's View turnoff, it becomes the park's eastern exit and most direct travel route to Death Valley Junction, Ash Meadows, Pahrump, Shoshone, and Las Vegas.

Specifically: Zabriske Point and Dante's View are Death Valley's most popular overlooks. On a clear day these respective views are stunning and unparalleled. They also reinforce the depth and magnitude of the Badwater Basin below.

> **Where:** Eastern side of park, from Furnace Creek Inn to Death Valley Junction and upper reaches of Black Mountains
>
> **Noted For:** Scenic overlooks, colorful badlands, wildflowers, higher elevations to escape heat of the valley floor
>
> **Best Times:** Late March, early April, October, November
>
> **Exertion:** Minimal to challenging
>
> **Peak Times:** March–April, early November
>
> **Accessibility:** Passenger cars to high-clearance 4WDs; restrictions on vehicle type and length for Dante's View and Twenty Mule Team Canyon
>
> **Parking:** Dedicated lots at Zabriske Point and Dante's View
>
> **Facilities:** Restrooms at Zabriske Point and lower Dante's View parking lots
>
> **Sleeps and Eats:** Closest park lodging options are Furnace Creek Inn & Ranch, National Park Service campgrounds at Furnace Creek, Texas Springs, and Sunset
>
> **Sites Included:** Zabriske Point, Echo Canyon, Twenty Mule Team Canyon, Dante's View

Furnace Creek Wash (36)

Just east of the Furnace Creek Inn, the Furnace Creek Wash defines subsets of the Amargosa Range. The Funeral Mountains head north toward Mud Canyon and Daylight Pass, while the Black Mountains extend south toward Saratoga Springs. On the pavement's south side is an alcove of golden badlands. These walls contain geometric patterns that look wonderful in late-afternoon light. As the pavement wraps south and east around the Black Mountains, sculptures of the dry wash and scattered foliage become more apparent.

During spring and fall storms, water collects here. On rare occasions the wash provides shelter for migratory birds that have been blown off course.

Continuing beyond Zabriske Point, the wash area expands on either side of the road. Even with casual observation you'll probably notice the effects of flash-flood activity etched into the creamy foothills. This terrain is brimming with linear compositions and looks best in soft morning light. Since sunrise lights up quickly at Zabriske Point and Dante's View,

you might stop here afterward to see if anything catches your eye.

Directions: East of the Furnace Creek Inn, CA 190 follows the path of Furnace Creek Wash. Some of the most interesting formations are within walking distance of the inn's easternmost parking lot. The wash and foliage areas begin around the corner and continue for about a 1/2-mile or so before opening up to more barren gullies.

Echo Canyon Road (37) 🌸🥾

Echo Canyon is located at the end of a rough backcountry road off CA 190. The 10-mile route begins with deep, bumpy gravel and ends as a coarse 4WD route. This terrain can be great for spotting wildflowers. Notch-leaf phacelia, beaver-tail cactus, gravel ghost, and desert gold are common here, even in stingy rainfall years. A wide variety of species is typically found about 2 to 3 miles in, at the base of rocky formations and along drainage patterns. Explore the area on foot to locate the most species. Echo Canyon Road is also a popular area for backcountry excursions. Camping is allowed beyond the 2-mile point, and many people operate out of this area for it's proximity to attractions in southern Death Valley. If getting out with camera gear is your thing, consider an overnight or backpacking adventure from Echo Canyon. The area's upper reaches are remote, with several hidden springs and occasional desert bighorn sheep sightings.

Cautions: The first few miles of the Echo Canyon Road are passable by most 2WD high-clearance vehicles, but beyond that point, backcountry driving skills and high-clearance 4WD vehicles are required. Should you decide on a hike or overnight trip from Echo Canyon, take all the water you'll need and then some.

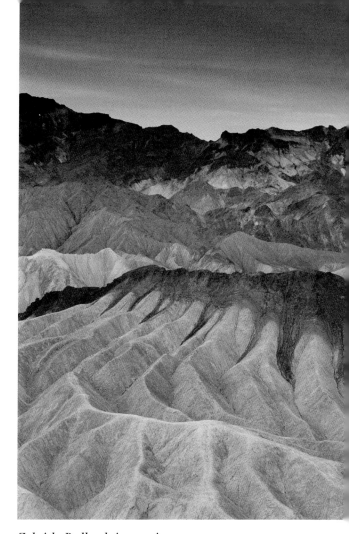

Zabriske Badlands in morning

Directions: Find the Echo Canyon road off CA 190 about 0.5 mile north of the Zabriske Point turnoff.

Zabriske Point (38)

This viewpoint is one of Death Valley's most popular—especially at sunrise. Manly Beacon is the star of this geological show, and it's likely to make an immediate impression. Though you'll definitely want to scout some possible compositions of this triangular formation, don't get overly involved in positioning your gear in its di-

rection. Complimentary light won't embrace the rippled sandstone until the sun is visible in the eastern horizon—plus you'll want to work the site's other opportunities.

Spring, fall, and winter offer the strongest Zabriske photo ops as these seasons typically generate the most interesting lighting conditions. If the clouds are too thick, sometimes the initial glow along the eastern horizon is all that's visible. On more promising mornings, color bleeds into the southern horizon, hovering above the folds of multihued badlands. Images are possible with all focal lengths, though the quality of light and cloud cover during your shoot will help determine the most engaging compositions. As the predawn color intensity fades, the western sky brightens, often casting tints of pink, blue, and lavender along the Panamint Range. Work anything you

find inspiring, and then prepare to transfer your gear and attention toward Manly Beacon. From this point, the golden foothills emerge from the shadows, revealing infinite studies in shadows, textures, and negative space.

Regardless of your strategy, certain tools will assist you in capturing the Zabriske light show. For glowing horizons and foreground detail, you'll need graduated ND filters or correct digital exposures of both sky and foreground for digital postprocessing. If the conditions surrounding Manly Beacon become soft and saturated, a middle- or long-range telephoto lens comes in handy. To render environmental takes on the beacon, choose a zoom lens in the wide to ultra-wide focal-length spectrum.

Zabriske Point can be a tough shoot if you're unfamiliar with the landscape or lighting pat-

Manly Beacon at dawn

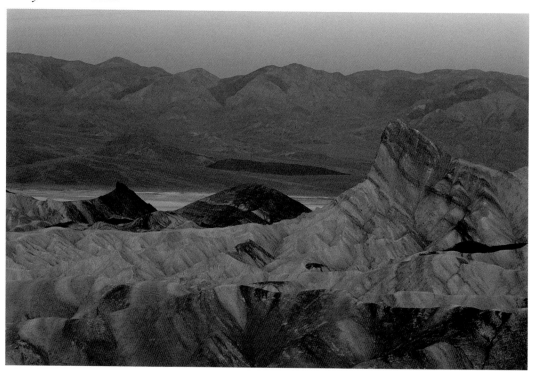

terns. Obviously seasonality and atmospheric conditions will hold significant influence on the above series of events. However, arriving 30 to 45 minutes before sunrise should allow plenty of time for you to record all the happenings. During spring months and times of ample wildflower blooms, you'll need to jockey among tourists and other photographers for the most coveted spots. By summer, cloudless skies add a great deal of challenge for creating interesting compositions. That's not to say opportunities won't happen—but you may have to work harder, or plan on capturing images before or just at sunrise.

Even with average reflexes—and some suggestions from this book—odds are high you'll bag a few nice shots while taking in some magical light. If you've never seen a desert sunrise, watching Manly Beacon light up can be a moving experience. Trust your instincts, and shoot frequently as the light unfolds. Quality light disperses quickly at Zabriske. Once gone, any illuminated sandstone loses definition, and harsh shadows fill the depressions.

Pro Tips: Though billed and best shot as a sunrise, Zabriske can also be a great spot to watch the sun drop behind the Panamints, especially when light cloud cover is present. Arrive 90 minutes or so before sunset for the best light. By this time the shadows have softened enough to compliment the folded terrain. On some afternoons, the golden badlands to the south take on a glowing aura, ripe with monochromatic and textural compositions. If you're shooting digital and have never experimented with creating black-and-white images, here's your chance. Submerge your mind in the lines and patterns. Shoot in color, and post-process with channel mixing and/or grayscale adaptation.

Should you decide the afternoon light is a total bust—and it sometimes is—don't forget to make some scouting notes for future shoots. Try various vantage points, and wander out into the siltstone foothills—noting your travel time—in search of fresh, unconventional compositions for days with better light.

Recommendations: It's almost always windy at Zabriske, so wear extra layers of clothing as well as gloves and a warm hat. I've seen too many photographers wishing they had gloves—even worse, those who missed great light running back to their vehicle to grab a pair.

Diversions and Cautions: The one official trail from the Zabriske area begins at ground level on the northeast side of Manly Beacon. This popular 2.5-mile hike is actually the top outlet of Golden Canyon. Portions of the trail and canyon walls remain shaded until late morning. Even a short stroll down this path reveals numerous compositions that incorporate shadows, texture, and monochromatic palettes.

Temperatures are most pleasant early in the day, especially in spring and fall. Winter can be chilly, while summer is quite warm—in fact, dangerously warm. Regardless of the season, it's important to carry enough water at all times and be prepared to stay longer than your initial plan. Consider, too, that the return trip to the Zabriske lot will be 950 feet uphill and in warmer temperatures than when you began.

Directions: From the Furnace Creek area, head 4.5 miles east on CA 190. Travel time is about 10 minutes. The parking lot for Zabriske Point is on the right.

Twenty Mule Team Canyon (39)

This one-way dirt road bounds through a series of golden brown hills in the upper Black Mountains. Given its name, you'd think twenty mule teams frequented this scenic byway—yet

oddly enough they didn't! Instead they traveled to Mojave via today's West Side Road and crossed the southern Panamints to deliver their goods. Anticipate your best photo opportunities to occur during early mornings and late afternoons when soft lighting compliments the terrain's rutted texture and leading lines. For contrasting color studies, juxtapose the chalky canyon walls against rich blue skies. The route contains numerous blind curves and limited shoulder area, so it's advisable to make an initial scouting pass to determine advantageous photo and parking spots.

Directions: The entrance to Twenty Mule Team Canyon is 5 miles southeast of Furnace Creek and 1.2 miles east of Zabriske Point. The 2.6-mile graded surface is suitable for most vehicles, including passenger cars—however, vehicles longer than 25 feet are prohibited from traveling on this road.

Dante's View (40)

Without question, this breathtaking vista is the premiere view of Death Valley's 110-mile span. At nearly 5,500 feet above sea level, Dante's View towers directly overtop Badwater, and the

Dante's View: Salt pan at dawn

sweeping view of the valley floor and surrounding mountain ranges serves as a textbook example of basin and range topography. Sunrise shoots are often wonderful here, even without clouds. Plan to arrive at least 45 minutes prior to sunrise time to scout compositions and capture morning twilight. As a rule, the eastern sky displays color first—ordinarily, palettes of peach, pink, and periwinkle. A snowcapped Charleston Peak looks great against these shades and is rewardingly photographed from the parking lot. Earth shadow is common in the northwestern sky and bodes equally tasteful colors. If eastern clouds are present, be sure to anticipate breaking sunbeams.

Good light happens fast at Dante's View. In fact, once the sun graces the Panamint Range, the best morning photo ops are pretty much in your camera—especially on mornings with clear skies. Because the salt pan and western Black Mountains slopes remain shadowed for some time, expansive blue sky scenes are best shot in late morning once the sun has crept higher in the southeastern sky.

For unobstructed views to the west and north, locate the trail at the far south end of the parking lot. Any of the rocky outcroppings along this path are excellent photo perches. Wide-angle lenses will allow you to craft encompassing views that incorporate foreground elements, salt pan, and sky. You'll also need a series of digital captures or grads to render lighting differentials. For tighter looks, try telephotos to emphasize colorful horizon segments or abstract patterns in the salt basin below.

For a truly celestial experience, spend a few hours on a summer night in the Dante's View parking lot. Besides getting a reprieve from the valley heat, you'll be treated to a personal planetarium. On the darkest nights, constellations and the Milky Way seem close enough to touch. You'll still see plenty of stars during fuller moon phases, too, but the allure of these

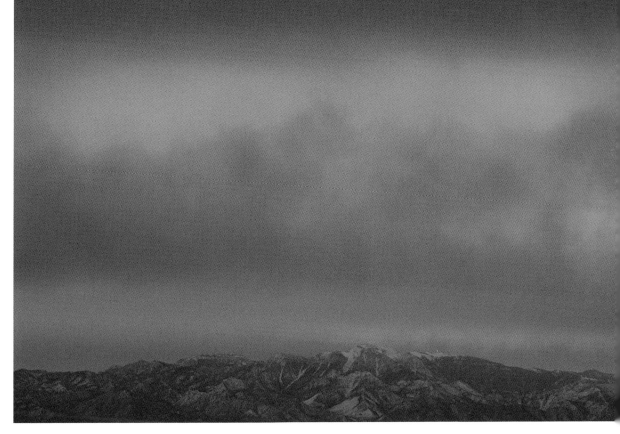

Charleston Peak in winter, seen from Dante's View

evenings is the illuminated salt pan. Peering down at the polished valley floor, you might have to remind yourself that the white stuff below is salt, not snow or ice.

Pro Tips: Though it's liable to be cold and windy, winter can be a spectacular time to shoot at Dante's View. Passing weather systems and promising clouds are more likely to occur, and the sun is at its lowest point in the sky at this time of year. Snowcapped mountains will probably surround the parking area. With Charleston Peak adorning the eastern horizon and Telescope Peak gracing the west, braving a little windchill could be well worth the effort— remember, some of the best light happens in less–than–desirable weather conditions. Expect air temperatures some 15 to 25 degrees cooler than the valley floor, and brave it out by wearing layers and donning ample warming accessories such as gloves, hats, and hand/feet warmers. Being prepared for similar conditions in spring and fall is worthwhile, too.

Directions: From CA 190, take the Dante's View Road and continue 13 miles to the main parking area. The paved road is passable by all vehicles less than 25 feet in length but is subject to closure during inclement weather. Trailer parking is available about 7 miles in. From the restroom pull off, the route twists and turns through the final 0.25 mile at a 15 percent grade. Though Dante's View is only 26 miles from the Furnace Creek area, you'll want to budget at least 50 minutes travel time—possibly more for a first-time approach in the dark.

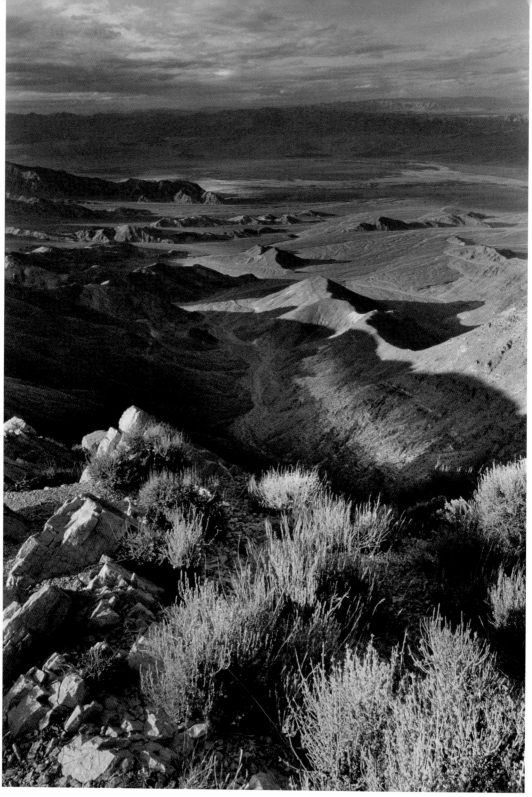

View from Aguereberry Point

Emigrant Canyon Road

SPRING ★ ★ ★ SUMMER ★ ★ FALL ★ ★ ★ WINTER ★ ★

General Description: The Panamint Range rises along the western border of Badwater Basin. Ridgeline overlooks and remains of several cultural stories are accessible here. You'll also find three free campgrounds and temperatures that are proportionately 20 to 35 degrees cooler than those at sea level and below sea level elevations.

Directions: The Emigrant Canyon Road heads southeast from CA 190. Locate the turnoff about 8 miles west of Stovepipe Wells Village or 20 miles east of Panamint Springs.

Specifically: This remote area is not as heavily visited as others in the park, and there are some legitimate reasons why. For starters, there are vehicle limitations, and the region is commercially undeveloped. Plus additional driving time and gas are required to reach the major destinations, not to mention the offshoot sites. And if magic-hour shoots are your thing, understand that either you'll be driving to lodging in the dark or have to stay at one of the campgrounds. On the other hand, if you're open to "roughing it" a little, there may be golden opportunities to photograph and experience seldom-visited sites and viewpoints.

Where: Foothills to highlands of the Panamint Range on the western side of the park

Noted For: Cultural-history sites, high-elevation hiking trails, ridgeline views, free campgrounds, lowest park temperatures in summer months

Best Times: Spring, summer, fall; summer days may be warm and bright, but nights will be cooler at Thorndike and Mahogany Flat Campgrounds

Exertion: Minimal to challenging

Peak Times: Spring, summer, and early November, when backcountry driving enthusiasts rule the area

Accessibility: Passenger cars to high-clearance 4WDs; vehicles longer than 25 feet not permitted on Emigrant Canyon Road; travel to Aguereberry Point and Eureka Mine restricted to high-clearance 4WD vehicles without trailers

Facilities: Restrooms at Charcoal Kilns, Wildrose, Thorndike, and Mahogany Flat Campgrounds; a water pump is available at Wildrose Campground

Parking: Dedicated gravel parking spots at Charcoal Kilns; informal areas at Wildrose Campground and Telescope Peak trailhead; shoulder parking at Lower Wildrose Station picnic area; a sizable parking area just off Emigrant Canyon Road provides parking for trailers or carpoolers en route to Eureka Mine, Aguereberry Camp, or Arguereberry Point

Sleeps and Eats: Closest park lodging options are Panamint Springs Resort and Stovepipe Wells Village; free camping at Wildrose, Thorndike, and Mahogany Flat; backcountry camping past the 2-mile point on Wildrose and Telescope Trails (register at trailhead, and follow "leave no trace" practices)

Sites Included: Aguereberry Camp Point, Eureka Mine, Wildrose, Charcoal Kilns, Mahogany Flat, Telescope Peak and Throndike

Aguereberry Camp (41)

Basque gold prospector and miner Pete Aguereberry's abandoned homestead—which he lived in until his death in 1945—lies at the base of Providence Ridge. Photographers who relish scenes of weathered Americana will definitely enjoy shooting this site. Peeling paint, mattress springs, rusted barrels, and defunct appliances present interesting opportunities for intimate texture and shadow compositions. Many of the buildings are sturdy enough to explore, so definitely set aside brainstorming time with multiple focal lengths. Besides the structures, you'll find a rusting car frame a short distance away. The exterior is a hodge-podge of colors and surfaces. A polarizer will enhance some of these qualities as well as the blue sky overhead.

Recommendations: For those of you traveling in passenger cars, you can access **Eureka Mine (42)** on foot by walking east on the two track approaching the rusted car. From the car, continue another 5 to 10 minutes or so to reach the parking roundabout and mineshaft.

Cautions: Be alert when exploring this area. Wear sturdy shoes, and carefully consider placement of your hands, knees, and feet. Glass, nails, and rusted debris are littered throughout camp, and it's also a safe bet that rodents and reptiles have moved in since Aguereberry's exodus.

Directions: From the Emigrant Canyon Road, take the Aguereberry Point Road. Look for the turnoff to the Aguereberry Camp about 1 mile in on your right. A sizable mound of dirt impedes additional forward progress. Tracks to

Derelict car at Aguereberry Camp

the side indicate that trucks or SUVs have driven around the dirt pile, but the road is not maintained and could contain tire-damaging debris. Unless you're in the mood to change a flat, play it safe and take the short walk to the campsite. The buildings are clearly visible, so you can't get lost.

Eureka Mine (42)

This gold mining operation prospered for some 40 years under the efforts of Pete Aguereberry. All that remains today are the primary mining structures and the shaft of the Eureka Mine. In fact, this well-preserved mine shaft is the only one in Death Valley certified for foot traffic by the National Park Service.

Most likely you'll arrive at this site in late morning or early afternoon as a side trip to or from the **Charcoal Kilns** (see site #45). The weathered tones of these architectural relics juxtapose nicely against a blue sky, producing striking images in color or black-and-white. The open skies and abrasive lighting may actually work to your advantage here, accentuating the gnarled structures and harsh climate. Use wide angles to capture the cashier mill against the sky and normal to moderate telephotos to identify tighter compositions. To photograph the full mine shaft entrance, you'll need a wide-angle lens.

Eureka Mine shaft

Pro Tips: When shooting from the outside looking in, frame your shot to include only areas in shade or total darkness. Spot meter off the wooden entrance, and exposure for the rest of the scene will fall into place. Setting the white balance for shade will warm up the in-camera file, or you can adjust the color temperature during postprocessing. The shaft entrance lends itself to both vertical and horizontal compositions, so definitely vary your camera position. If it's a hot day and you've worked up a sweat, step inside and shoot looking out. The temperature is noticeably cooler, even just a few feet inside the entrance. Again, a wide angle is probably the lens of choice. This time, meter the outside world, and toy with fill flash intensity and positioning to illuminate the entrance.

Recommendations: An interpretive sign mentions that the mine may be closed to protect bats. If you are planning a special stop at Eureka Mine, definitely confirm current access conditions with the Furnace Creek Visitor Center.

Cautions: Exercise caution when walking around the cashier mill and other wood remnants. The amount of debris in this area may also result in tire damage. Navigate the parking area carefully, or consider walking over from the Aguereberry Camp. For those interested in mine exploration, park service signage recommends two flashlights—one as your primary, the second as backup.

Directions: From the Emigrant Canyon Road, turn onto Aguereberry Point Road, and travel 1.2 miles. Take the offshoot to your right, and continue another 0.8 mile to the Eureka Mine turnabout and interpretive marker.

Aguereberry Point (43)

The remarkable persistence of Pete Aguereberry—who first began looking for gold here around 1900—made him one of the most famous prospectors in the Panamint Range, so it's quite fitting that his namesake graces this stunning Death Valley overlook. Scenes from this remote point are spectacular. Accessible only by high-clearance 4WD vehicles, this spot is sweetest during late afternoon and into sunset. You'll likely encounter the best light a couple of hours before sunset, especially if there are a few clouds in the sky.

Windows of opportunity can happen fast here, so technical comfort with your gear is a plus. The valley and canyons below are quickly shadowed by the Panamints once the sun begins to drop. Be prepared to work with graduated ND filters, or capture a variety of digital exposures to compensate for the broad range of lighting and tonality, especially when using wide-angle lenses. After sunset you might be able to capture valley texture and Earth shadow if the eastern horizon is free of clouds and haze.

Spring and late fall are the best seasons, although summer shoots are possible here as well. While temperatures in the Panamints will be considerably cooler than those in the valley, it will still be hot and the sun's rays intense. Thick haze and cloudless skies in late spring and summer can significantly reduce scenic potential. If haze is a factor during your visit, consider applying travel time and resources to photographing other areas in the park.

Recommendations: The elevation at Aguereberry Point is 6,433 feet, and the wind can be relentless. It's also steep and rocky all the way down. Carry your gear to the rise of the rock formations, and then explore the terrain pack free as you scout your spot(s). Fortunately, you don't have to be a rim runner to get a nice shot here. Rather than teetering on the edge, use a wide-angle lens to incorporate rocks and foliage as interesting foreground elements.

Cautions: Keep in mind this is a day-use area, and you'll be driving the rough road back in the dark. From experience I can tell you it's a slow, dusty drive with limited nighttime visibility.

Directions: Locate the rough dirt road to Aguereberry Point off the Emigrant Canyon Road. This road is also signed as the turnoff for Eureka Mine and Harrisburg Flats. Continue eastbound to the parking area just below the rocky crest. Signage restricts trailers and recommends high-clearance 4WD vehicles.

Wildrose Station Picnic Area (44) ⚝⚞

This site is one of the more pleasant picnic spots in Death Valley. Abundant foliage and tiered table placement provide a rare combination of solace and shade. The layered stonework is all that remains from a former motel and gas station. In the spring, nonnative oleander bushes produce colorful pink blossoms and attract a variety of animal life. Yellow war-

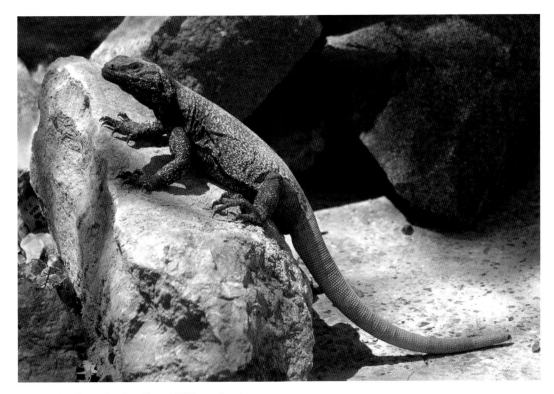

Desert-dwelling chuckwalla at Wildrose Station

blers will serenade you from overhead branches while chuckwallas rustle about in lower-lying flora. The oleander flowers are pretty, but shooting them may test your tenacity and patience. Wind and high-contrast lighting are often issues here. Work in shade if you can find it, though having access to diffusers and reflectors is even better. In this setting, telephotos offer greater versatility than macros. They'll provide you more working room around the branches and assist in softening backgrounds. Plus, you'll be ready to photograph either birds or reptiles should opportunities occur.

Diversions: Continuing west on this route, you'll encounter many canyons and drainage areas—some with enjoyable flower spreads after sufficient winter precipitation. If you're planning a springtime Panamints trip, definitely obtain current flower information. During premier conditions you might even see the Panamint daisy. This Death Valley endemic is occasionally sighted in gullies of an unnamed canyon about 0.5 mile past the picnic area.

Cautions: Navigate this short stretch of road carefully. The pavement is rough, narrow, and abounds with potholes. The surface actually improves in some spots when the pavement shifts to gravel. Also note that vehicles longer than 25 feet are prohibited from traveling on this road.

Directions: Follow Emigrant Canyon Road as it descends through Nemo Canyon. A bridge crossing will indicate your arrival in the Wildrose Canyon area. Immediately past the bridge, turn right, and continue about 1.5 miles. This road, casually referred to as Trona-Wildrose

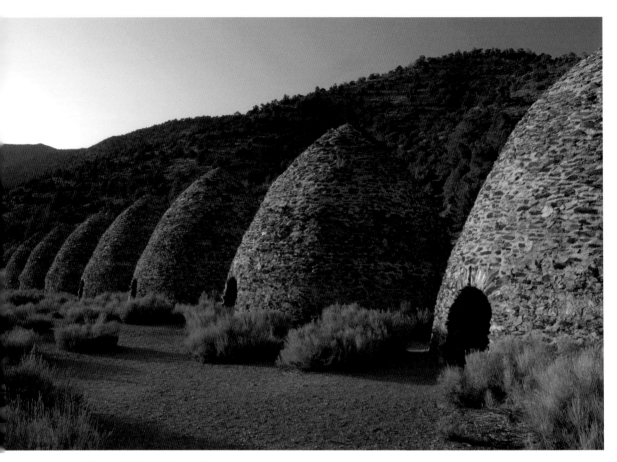

Charcoal Kilns in late afternoon

Road or Lower Wildrose Canyon Road, is clearly marked but often unnamed on park service materials. Picnic tables and parking pullouts are located on both sides of the road.

Charcoal Kilns (45) 🐾

Nestled high in the Panamint Range these beehive-shaped structures are truly a curious sight. The Charcoal Kilns were designed by Swiss engineers and built by Chinese laborers in 1879. Each kiln held about 42 cords of pinyon pine logs, yielding two thousand bushels of charcoal after a week-long burning session. During their three years of use, these kilns produced charcoal for the Modock Mine

smelter located about 30 miles away. Thanks to such a brief period of operation, their remote location, and restoration work done in the 1930s and 1971, these may be the best preserved kilns in the West. Unlike many cultural sites in Death Valley, the kilns are safe for exploration. Wander inside these 25-foot structures to experience their lingering charcoal scent and eerie acoustics.

An ultra-wide-angle lens is necessary to capture all 10 structures in the same frame. The kilns will be shaded at sunrise and sunset, so don't waste magic-hour time here. Plan to photograph them either in late morning or late afternoon. Midday has possibilities, too, though

contrasty conditions and diluted color palettes are likely. For a late-morning shoot, walk behind the structures and use the embankment to raise the camera's point of view and add interest to your composition. Since you're facing northwest with the sun falling over your shoulder, using a polarizer will add punch to the blue sky. In late afternoon, the kilns will begin to glow as the sun falls in the western horizon. Try using grasses, sagebrush, or spring flowers to add interest in your foreground. Don't be afraid to explore a variety of compositions and vantage points. Also ponder using shorter focal lengths to work the arched entrances, graphic patterns, and themes of repetition.

Once the kilns are shaded, the strongest compositions looking east are gone, and you really don't have enough time to get anywhere for a great sunset shot. Depending on the time remaining in your visit and plans for the next day, there are various strategies.

When the atmospheric cards have been dealt in your favor, lovely clouds will hover above the Sierra Nevada range. Photograph from the embankment behind the kilns, and utilize graduated ND filters or multiple digital captures to offset lighting differences. For film shooters, creating nighttime exposures is a creative option. Again, shooting from the embankment maximizes the amount of northwest sky and interesting star-trail activity in your composition.

If the clouds aren't to your liking and toying with night photography isn't your thing, it's time to consider where you'll be the next morning. If hiking Wildrose Peak or Telescope Peak sounds appealing, head to one of the nearby campgrounds. Those driving passenger cars can stay at Wildrose Campground to tackle Wildrose Peak. For those with high-clearance 4WD vehicles, Thorndike or Mahogany Flat Campgrounds are closest, and reaching either trailhead is an option. Or simply push out in the morning, and, if time allows, plan to visit the cultural sites on your way out if you didn't explore them en route to the kilns. Lastly, you could drive back to lodging or camping in a more developed area in the dark. If you're lucky enough to be staying at Stovepipe Wells, the sand dunes are a convenient sunrise shoot.

Directions: From the Wildrose Campground, continue southeast on the Emigrant Canyon Road another 7 miles. After about 2 miles, the pavement shifts to a maintained gravel surface. This portion of the road is accessible by most vehicles when free of snow and ice.

Wildrose Peak Trail (46) 📷🥾

Hiking Wildrose Peak is a moderately strenuous adventure that yields expansive to panoramic views. The trail climbs 2,200 feet and covers 8.4 miles round-trip. If you're planning to shoot the Charcoal Kilns in the late afternoon, consider doing some or all of this trail in early- to mid-afternoon. After a short uphill start, the trail levels a bit. On the left are some large rock formations scattered with cacti and Indian paintbrush. With impeccable timing, this area produces a great foreground for the distant Sierra Nevada range. The recommended time window is mid-May to early June, though what's blooming will depend on the previous winter's precipitation and the current spring's warming pattern.

From here the trail continues steadily upward, through a forest composed of juniper and pinyon pine. Beyond the 2-mile point, you'll encounter dramatic views across the salt pan. This can be a nice place to begin locating some shots. Besides the obvious expansive views, try your hand at possible midrange subjects. Weathered and charred tree skeletons pack plenty of character and look great against azure blue skies. Eventually the trail rises above the treeline, and unobstructed views abound.

The last mile is a fairly steep grade, but it's worth the effort for the panoramic vista.

In addition to camera gear, you'll need to pack plenty of water for this hike. If you're unaccustomed to hiking in an arid climate or at elevation, bring more water than you think you'll need. This may mean taking less camera gear than you'd like, but you'll be happier getting some shots with limited gear than turning back early on account of dehydration. A single camera body with a comprehensive zoom should get the job done.

Recommendations: Even if the temperature feels warm at the Charcoal Kilns, take a light jacket or fleece to prevent getting chilled above the treeline. To maximize your experience, pack a picnic lunch to enjoy at the summit view.

Cautions: Juniper and pinyon pine trees offer patches of shade, but the sun is still intense. Don't forget your sunscreen, brimmed hat, and sunglasses along with the water you'll be packing.

Directions: The Wildrose Peak trailhead is located at the north end of the Charcoal Kilns.

Thorndike (47) and Mahogany Flat Campgrounds (48)

While not true photo destinations in their own right, Thorndike and Mahogany Flat Campgrounds are hardly lacking in possible subjects. Wind-warped juniper and pinyon pines translate to terrific texture studies and are plentiful throughout both campgrounds. Birds, lizards, rabbits, and deer also occupy this terrain, so with some patience and a little luck, you might even have the opportunity to photograph wildlife at these campgrounds. Additionally, these free sites are convenient spots to camp for those wishing to photograph and hike trails in the Panamint Range. Sleeping over at these

elevations will not only save you gas money and travel time, but it will assist your body in acclimating to high-altitude conditions. Of the two sites, Mahogany Flat has better views and more private campsites. Winter camping is allowed, though preparation, awareness of weather conditions, and a high-clearance 4WD vehicle to maneuver through snow are musts.

Cautions: Past the Charcoal Kilns, the road is rough, winding, and steep in places. The park service strongly recommends high-clearance 4WD vehicles beyond the Charcoal Kilns, but capable drivers in a high-clearance 2WD vehicle should be OK when the road is snow free.

Directions: From the Charcoal Kilns, continue roughly 0.5 mile to Thorndike. Continue another mile to reach Mahogany Flat and the Telescope Peak trailhead.

Telescope Peak Trail (49) 🌰🌿

Given Telescope Peak's elevation of 11,049 feet, the 360-degree view from the top is a jaw-dropper. Telescope's summit is the highest point in Death Valley National Park, and the vertical drop from this peak to the Badwater Basin below is twice the depth of the Grand Canyon. On a clear day there are mountain ranges as far as you can see. The two standout peaks are Mount Charleston, as you look east, and Mount Whitney, topping the Sierra Nevada range to the west.

Summiting Telescope Peak is not for the out of shape or those afraid of heights. Though the trail is in decent shape and fairly easy to follow, it is often narrow and borders steep ravines. A round-trip to the top covers 14 miles. Despite a gradual gain of just under 3,000 feet, the starting elevation of 8,133 feet can be physically taxing, especially if you've spent the night near or below sea level. Thankfully, it isn't necessary to hike the entire trail to find great photo

opportunities. Traveling even the first 2 miles provides stunning views looking down into and eastward across Death Valley. Continuing another 1.5 mile or so sends you around the east side of Rogers Peak and sets up an ascending view of the Telescope summit. Venture to the halfway point, and you'll be rewarded with ridgeline views east and west as the trail navigates Bennett Peak. Beyond that, conditions get colder and windier. Vegetation here is limited to some of the heartiest species on earth, including stubby barrel cacti and ancient bristlecone pines. These enduring pines— some of which have survived thousands of years in adverse growing conditions—have purple cones and are usually found at elevations above 10,000 feet.

If this hike is within your physical capabilities, I highly recommend it for the experience and views. With no dependable water source along this trail, a good portion of your pack weight will be devoted to water. Given the altitude, arid climate, and likeliness that you will be taking in midday views, choose your camera gear carefully. Consider taking one body with a comprehensive zoom lens. If you have the option of a lightweight tripod, I would definitely recommend taking it over a heavier model.

Cautions: Past the Charcoal Kilns, the road gets rough, winding, and steep. The park service highly recommends a high-clearance 4WD vehicle beyond the Charcoal Kilns—especially in winter—though experienced drivers in a high-clearance 2WD vehicle should be OK when the road is clear of snow.

Recommendations: Speaking of snow . . . If you notice any on Telescope Peak from the valley floor, definitely check with the Furnace Creek Visitor Center for the most recent trail report and special gear recommendations.

Directions: From the Charcoal Kilns, continue about 1.5 miles until the road crests at the south end of the Mahogany Flat campground. Find the Telescope Peak parking area straight ahead and trailhead registration just to your right.

Bristlecone pinecones on Telescope Peak Trail

Panamint Springs

General Description: Death Valley's current western boundary was redrawn by the California Desert Protection Act of 1994. Though this side of the park is not as heavily documented, it certainly isn't lacking in photo opportunities, and the Panamint Springs Resort is a great home base for exploring Emigrant Canyon and the Panamint highlands.

Directions: The heart of Panamint Springs is located 22 miles inside Death Valley's western border. CA 190 winds though this area and sets up easy travel routes to Lone Pine, 48 miles west, and Stovepipe Wells, 36 miles to the east. Mileage between Panamint Springs and Furnace Creek is 60 miles.

Specifically: Alluvial fan foothills to colorful highlands cutting through Towne Pass and Rainbow Canyon dominate the vistas. In addition, there are accessible opportunities to experience desert flora at the fragile Darwin Falls oasis and Joshua trees at Lee Flat Joshua Trees.

Emigrant Campground (50)

Though I wouldn't consider it a jaw-dropping photo destination, this free campground might be a convenient place to hang your hat for the night. Unobstructed views of the Cottonwood and Grapevine Mountains provide you with winning opportunities to combine alluvial fan textures with polarized skies. Early-morning light just after the magic hour will showcase the abstract geology of the Cottonwood Mountains. When winds are calm, try incorporating creosote bushes into your foreground. On blustery days, stand atop the picnic tables and use telephoto lenses to create midrange mountain studies.

Sunrise light may cooperate here, too, though it's tough to imagine exhausting all the possibilities at the Mesquite Flat sand dunes

Where: Most accessible attractions on the western side of the park

Noted For: Colorful canyons, desert flora

Best Times: Spring and fall—thick summer haze will hinder sunset potential at Father Crowley Point; early spring and years of above-average rainfall are most desirable to shoot at Darwin Falls

Exertion: Minimal to moderate

Peak Times: Spring and fall

Accessibility: Passenger cars to high-clearance 4WDs; during winter precipitation, consult Furnace Creek Visitor Center regarding current conditions to Lee Flat

Facilities: Emigrant Campground features a pay phone, water, free campsites, and flush-toilets; Panamint Springs has an unpaved airstrip and a convenience store with gas and diesel fuel, snacks, and souvenirs; restrooms, free wireless Internet, and an air/water pump also available

Parking: Dedicated lots at Emigrant Campground and Father Crowley Point; parking also available at Panamint Springs Resort properties; informal parking at Lee Flat and Darwin Falls trailhead

Sleeps and Eats: The small, rustic Panamint Springs Resort offers both lodging and a full-service restaurant serving tasty and reasonably priced breakfast, lunch, and dinner; shaded camping and RV spots with hook-ups and showers are located across the street

Sites Included: Father Crowley Point, Darwin Falls, Lee Flat Joshua Trees, Emigrant Campground

just a short drive away. Once the best light has left the dunes, come here for a few frames before catching a bite or heading to your next location.

Directions: Emigrant Campground is located about 9 miles west of Stovepipe Wells on CA 190. With only ten tent sites, expect Emigrant to fill quickly during peak seasons and strong flower years.

Darwin Falls (51)

Braving the marshy brush to reach this intimate oasis will transport you to an environment that's completely opposite most others in Death Valley. In fact, you might even forget the surrounding terrain is located in one of the hottest, driest places on the planet. Darwin Falls cascades year-round and serves as the local water source for the Panamint Springs area. Of course, the time of year and recent rainfall will have direct effects on the amounts of water and foliage. As you would expect, springtime and damper years foster the best conditions and reward visitors with flowering plants, dragonflies, and western toads. Birds and chuckwallas are also common in rocky approach areas.

Regardless of when you visit, navigate the area carefully as it is both a fragile landscape and a public water supply. If traveling with others, tread lightly in a single file to help preserve this delicate ecosystem. The falls are approximately 1 mile from the parking area. Occasionally, trail visibility might challenge your route-finding skills and lengthen the walk. The closer you get to the falls, the thicker the foliage can become—at times the flora obscures the trail, topping my 5-foot-3-inch height. When possible, keep to the left, and hug the canyon wall until you appear front and center at the pool of water below the falls.

Directions: Locate the Darwin Falls access road about 1.2 miles west of the Panamint Springs

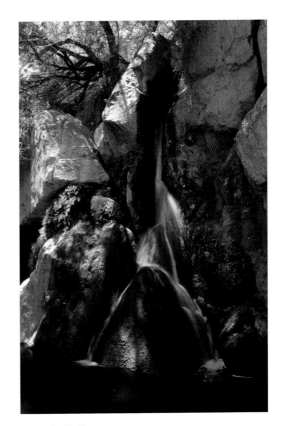

Darwin Falls

Resort. The 2.5-mile dirt road is bumpy but usually passable by passenger cars.

Father Crowley Point (52)

This vista surveys a landscape of dark lava flows and volcanic cinders before transitioning to the vivid textures of Rainbow Canyon. Afternoons and evenings during spring and fall offer the best photographic potential as late light illuminates sweeping views of the Cottonwood Mountains and colorful canyons below.

Wind is often a factor here, making stable in-focus foregrounds a real bear. Instead, use the graphic qualities of canyons or roadways to set up leading lines and strengthen your compositions. Grads or multiple digital exposures will be necessary to offset lighting differences

between the eastern sky and deeper terrain. If cloudless horizons generated a less-than-stellar sunset, be patient: eastern skies often give way to colorful bands of Earth shadow during evening twilight. Wide-angle lenses and telephoto zooms will enable you to seek out compositions at a variety of focal lengths.

Cautions: Parts of the Father Crowley Point access road are rough, especially beyond the

Joshua tree at Lee Flat Joshua Trees

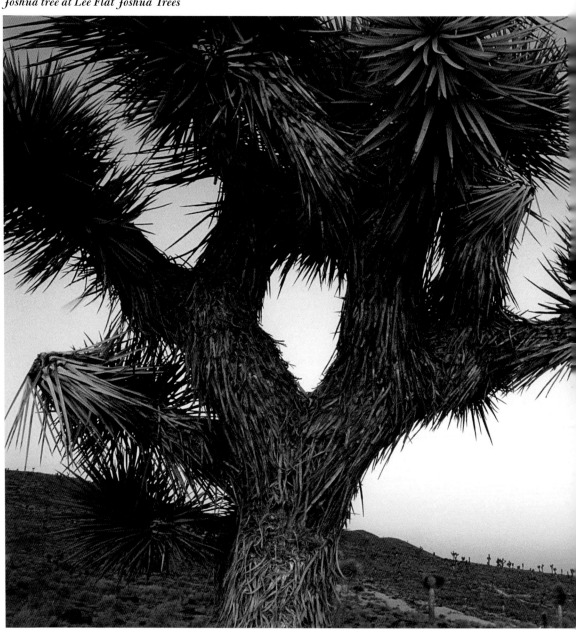

second viewing area—I wouldn't recommend taking a passenger car past that point. It's only a short walk to the third overlook, and erring on the side of caution during desert travel is never a bad thing.

Directions: Three viewing areas are accessible by a dirt spur off CA 190 roughly 10 miles west of Panamint Springs Resort. After ascending a 4.7 percent grade, the road levels out before the northbound turnoff.

Lee Flat Joshua Trees (53)

Joshua trees *(Yucca brevifolia)* are an indicator species and a true icon of the Mojave Desert. Their twisted limbs convey stories of perseverance and resilience. An important part of the Mojave ecosystem, Joshua trees provide habitat for birds, mammals, insects, and lizards. To catch the species in bloom, visit the stand in late May to early June.

If your time in Death Valley is limited, chances are you will venture to Lee Flat somewhere between late morning and early afternoon on your way between prime sunrise and sunset locations. If so, make the most of bright-blue skies by featuring the northern horizon in your compositions. Using fill-flash will soften midday light and shadowed portions of the trees. To incorporate radiant afternoon light, compose your shots facing east. Should late-afternoon creative juices get the better of you, don't worry about traveling to an iconic Death Valley spot. Instead, stay put and let the magic hour kick in. Sunsets and rich twilight hues deliver fantastic backdrops for Joshua tree torsos. Scope out trees with interesting profiles, and fashion them against a generous skyline.

Directions: This stand of yuccas is quite impressive and much more accessible than the one along Racetrack Road. From Panamint Springs Resort, follow CA 190 west about 13.7 miles to Saline Valley Road. Turn right, and travel about 8 miles to the Joshua trees. The road surface begins as roughed-up pavement and shifts to gravel near Lee Flat Junction. At this point gravel spurs in either direction lead to nice views of the forest.

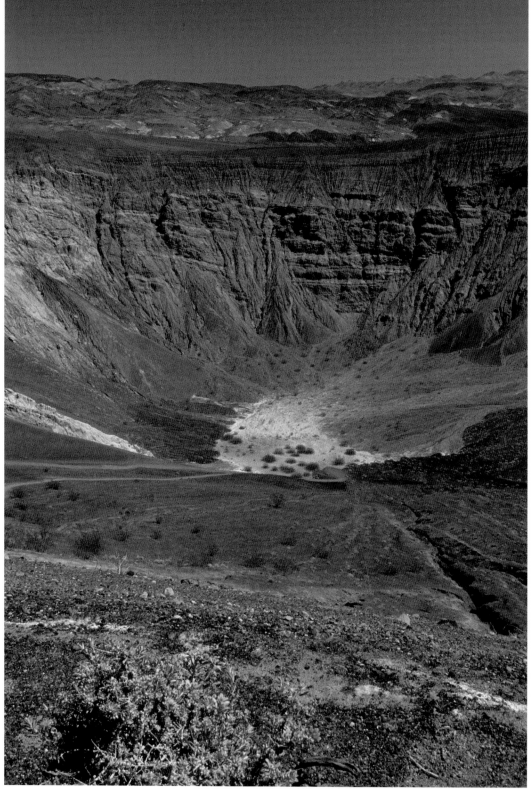

Ubehebe Crater

Grapevine Canyon

SPRING ★ ★ ★ ★ SUMMER ★ ★ FALL ★ ★ ★ ★ WINTER ★ ★

General Description: Traveling to and from the Grapevine area can absorb an entire day. There aren't any coveted sunrise spots here, so beginning your morning at the Mesquite Flat sand dunes is a worthwhile strategy. If you're camping at Mesquite Springs, try shooting the eastern slopes of the Cottonwood Mountains in early light. From either area, head to Scotty's Castle, and spend the better part of the day there. In late afternoon visit the Ubehebe Crater field, and return south for convenient sunset opportunities at Devil's Cornfield or Cottonball Basin.

Directions: The Grapevine Canyon area lies about 32 miles north of the CA 190/Scotty's Castle Road junction.

Specifically: Elevations at Grapevine linger in the 3,000 feet range and offer a slight reprieve from summertime heat. Aside from being cooler, they're also more likely to catch precipitation than other highly trafficked sections of Death Valley. Wind can be prevalent at the crater field and on the hills overlooking the Scotty's Castle grounds.

Where: The Grapevine Canyon area, including the crater field and Scotty's Castle

Noted For: Otherworldly terrain, stunning architecture

Best Times: Spring and fall

Exertion: Minimal to moderately challenging

Peak Times: March–April, early November

Accessibility: All roads accessible via passenger car

Facilities: Restrooms at Grapevine Entrance Station and Scotty's Castle

Parking: Dedicated lots at Grapevine Entrance Station, Ubehebe Crater, and Scotty's Castle

Sleeps and Eats: Within the park, Stovepipe Wells Motel has the closest lodging; outside the park (68 miles away via Scotty's Castle Road/NV 267 and US 95), Beatty, Nevada, offers a number options; the most convenient camping is at Mesquite Springs Campground near the Grapevine Entrance Station; a modest snack bar is available at Scotty's Castle

Sites Included: Ubehebe Crater, Little Hebe, Scotty's Castle

Ubehebe Crater (54) 📷✎

The eerie terrain around this maar volcano is best photographed from early afternoon to evening. Most days you'll find the crater in complimentary light until sun approaches western ridgelines. Glowing, translucent clouds may improve chances for special images in this area, while denser formations will flatten out available light more quickly. Regardless, you'll need to meter light differentials between the sapphire sky and burnt orange crater walls. Use graduated ND filters or multiplex a series of digital files to ensure balanced compositions.

The circumference of Ubehebe Crater is about 1.5 miles. Though it's not necessary to circle the rim, walking away from the parking area is worthwhile to obtain different looks and backdrops. While an ultra-wide-angle lens is the best bet for photographing the big crater, it's not the only way to interpret this landscape. Another option is visiting nearby **Little Hebe**

(55). From the parking area, follow the western offshoot for about 0.5 mile. Shifting cinders prevent the formation of an established trail, though regular foot traffic maintains the route's visibility. Little Hebe is the largest of many smaller craters that are thought to be the area's youngest formations. Their well-defined rims translate to terrific leading lines and often yield more compelling compositions than the big crater. Featuring the many desert holly and sagebrush plants adds interest, too, especially when backlighting generates glowing auras. And when precipitation patterns are favorable, vibrant spreads of purple mat pepper the cinder field—usually in mid- to late May.

Diversions: If you're OK with an uphill return, then visit the floor of this massive crater. Pooled

Purple mat

water (or wet clay) are common in damper years or after a recent rainfall, and the crater's 600-foot depth often silences the wind, creating reflective water surfaces. Follow the moderately defined 0.25-mile path for the easiest descent, keeping in mind that your return along this cinder-strewn terrain will be more arduous on the way back up.

Cautions: Expect strong winds to accompany you along this terrain. Only once when I visited was the air relatively still, and I'm now convinced that day was an anomaly. Vigorous gusts toss often around the volcanic cinders like dust. These particles can be piercing to skin, especially your face. I would strongly consider wearing sunglasses to protect your eyes and using hoods and caps to safeguard lenses. Exercise caution when cleaning debris, and take special care during lens or film changes by using your body as a shield.

Directions: Travel north on the Scotty's Castle Road, and pass through the Grapevine Entrance Station. The turnoff for Ubehebe is just a short distance farther on the left. Stay on the paved route, and continue about 5 miles to a small parking area.

Scotty's Castle (56) 🌸

Of all the miners in Death Valley's history, it's possible that Walter Scott scored the biggest payday of them all—off a fictitious excavation. The ultimate con man, Scott spun elaborate stories about a promising Death Valley goldmine and reaped a small fortune from awestruck investors. Of his generous backers, only Albert Johnson traveled to see the project firsthand. With no tangible operation to show, Scott relied on his personable appeal and pathological lies, which he kicked into high gear—so much so that Johnson could have cared less about the mine. Instead, he and

Scott unearthed something much more precious: the friendship of a lifetime. As Johnson's trips to Death Valley grew in length and frequency, his wife pushed for a vacation home in Grapevine Canyon. Formally known as Death Valley Ranch, the elaborate grounds were spared no exemption from Walter Scott's audacious anecdotes, and it wasn't long before the lavish residence became known as Scotty's Castle. Amazingly, Johnson remained unfazed, valuing Walter Scott's wit and companionship far more than the name of his homestead.

Much like other parts of Death Valley, the castle is a study in extremes. Construction—integrating sophisticated plans and premium materials—began in 1922, a testament to the economic boom of the Roaring Twenties. Sadly, the grand endeavor stalled in 1933—a victim of zoning issues and the Great Depression's crumbled economy. Today nearly all of the quintessential period details remain, thanks to meticulous preservation by the National Park Service.

Besides the main house, the grounds feature several other buildings with Spanish-style architecture. Definitely set aside time to explore the **Deagen Chimes Tower**, **powerhouse**, **guesthouse** (hacienda), **stables**, and **historic car collection**. In addition, there are opportunities to photograph petroglyphs, cholla cactus, and date palms near the watercourse. The scope and quality of thematic elements is extraordinary. Similarly, possible compositions range from grand to intimate, and I expect your mood and overhead lighting conditions will help define appealing subjects. In winter months it's possible to experience the castle during the evening magic hour. And though the castle itself doesn't benefit from stellar evening light, you'll encounter unique image opportunities by incorporating silhouettes and shadows. Watch for patterns and projections of ornamental lighting sources and wrought iron.

Scotty's Castle framed in the gate

Another option is hiking the **Windy Point Trail** to photograph **Scotty's grave** in evening twilight.

Access to the castle's interior is available via two National Park Service tours. The **Living History Tour** walks visitors through the main house (guides adopt a 1939 wardrobe and persona for the duration of the program), and along the way you'll be treated to colorful tales

and exquisite decor, including European antiques, hand-selected tapestries, iron chandeliers, custom-tile floors, and handmade Spanish Majorcan rugs. Despite being wonderfully informative and entertaining, the tour presents definite challenges for photographers. For starters, tripods and bulky packs are not allowed inside. Foot traffic is restricted to designated surfaces, and touching walls or fur-

Spiral staircase, Scotty's Castle

nishings is not permitted. You'll be firmly encouraged to remain close to the group, making it difficult to compose without human or flash interference. In addition, indoor lighting is limited so you'll need to work with high ISOs and faster f-stops. On-camera flash is somewhat workable, but the lighting constraints and high ceilings will consume some serious battery power. You'll find similar creative challenges on the **Underground Mystery Tour**, though limited access to the mechanical subject matter doesn't seem quite the concession. This tour, conducted by a uniformed park ranger, explores the castle's basement, cutting-edge technology, and subterranean tunnel system.

Living History Tours are presented several times each day. On holidays and in peak months (November through April) the park service recommends purchasing tickets upon arrival since tours often sell out. Underground Mystery Tours run daily November through April and as staffing allows during summer. A special combination ticket saves $1 off each tour (House and Underground) if purchased at the same time.

Diversions: If you're driving a passenger car and interested in visiting a dry lake bed, consider **Bonnie Claire Flat Playa (57)**. Though its location is not as ghostly as the **Racetrack (58)**, the terrain is quite similar. Upon exiting Scotty's Castle, turn left, travel about 21 miles to the Nevada state line, where you'll find the playa on the left.

Directions: The castle is located on Scotty's Castle Road, 38 miles north of the road's junction with CA 190. Travel time from Stovepipe Wells is about 50 minutes; from Furnace Creek, allow 1 hour. Hours of operation and access to grounds vary seasonally. Obtain current information during your visit by calling 760-786-2392.

Backcountry Adventures

General Description: This remote route accesses some of Death Valley's most popular backcountry attractions. The Last Chance Range graces the northern horizon and occasionally its prominent summit, Dry Mountain, becomes an outstanding snowcapped subject. In addition, there is plenty of scenic variety and increased vegetation as a result of higher elevation and greater precipitation.

Directions: All subjects border Racetrack Road, west of Ubehebe Crater.

Specifically: The Racetrack is renowned for its barren playa and legendary sliding rocks. Teakettle Junction is a charismatic work-in-progress and makes a great subject almost any time of day. The Joshua tree stand is easily accessible and intermingled with cholla and barrel cactus. With the right mix of winter precipitation and moderate spring temperatures, wildflower displays along the first few miles of Racetrack Road can be quite pleasant. May is a good month to explore this area, and it's possible to see desert gold, desert five-spots, desert trumpets, and purple mat when desirable conditions converge.

The Racetrack (58) 📷📷

Of all of my Death Valley images, none conjure more wonder and questions than those from The Racetrack—and for the same reason, most photographers yearn to visit this remote playa. Should you heed the calling and have a trusty, high-clearance ride, then prepare for a lengthy butt-numbing drive. Along the way you'll encounter a wonderful **Joshua tree forest (59)**, the looming summit of **Dry Mountain (60)**, and the enigmatic **Teakettle Junction (61)**.

Where: The Racetrack Road and worthy subjects along the way
Noted For: A prominent Joshua tree forest, quirky signage, mysterious geology
Best Times: Spring and fall
Exertion: Minimal to moderately challenging
Peak Times: March–November
Accessibility: Well-maintained, high-clearance vehicles only; often restricted to 4WD, depending on road conditions
Facilities: None—this is serious desert backcountry!
Parking: Limited pullouts along Racetrack Road, informal parking space at Racetrack Playa
Sleeps and Eats: Only the primitive and informal Homestake Dry Camp
Sites Included: Joshua Tree Forest, Dry Mountain, Teakettle Junction, The Racetrack and Grandstand

During late spring and early summer, it's possible to locate a variety of blooming flora, including paintbrush, primrose, yucca, and cacti—courtesy of higher elevations, cooler temperatures, and greater precipitation.

The legendary sliding rocks are mesmerizing both in story and sight. Their sweeping trails provide outstanding composition potential using many focal lengths. Experiment with a variety of vantage points and aperture settings to depict shadows and patterns of the dry lakebed. Generally speaking, the south end is the best area to find rocks, though I have seen trails with and without rocks throughout the playa. Sadly, there's no guarantee rocks will be present. People do steal them, and occasionally you'll detect tire tracks on the playa surface.

Joshua tree forest cloaked in snow

As a rule, The Racetrack's sunrises tend to be more generous with photo ops than sunsets. However, both have potential, and the look of mornings is decidedly different from evenings. If you're heading out to catch the early light, make sure to set your alarm clock for ample transit time. The light happens fast here, and arriving 20 to 30 minutes late really isn't worth the expenditure in time and gas. Travel can be slow going in the dark, especially if you've never driven Racetrack Road before. The rough road surface kicks up lots of dust, creating poor visibility much like white-out driving conditions.

north to south, with the Grandstand formation gracing the northernmost end. Mull over this orientation, and hunt for sliding rocks or geometric elements that will benefit from early light in the eastern horizon. After selecting your subjects, make notes on the time it takes to reach your vehicle and campsite since they will be valuable the next morning.

Sliding rocks at The Racetrack

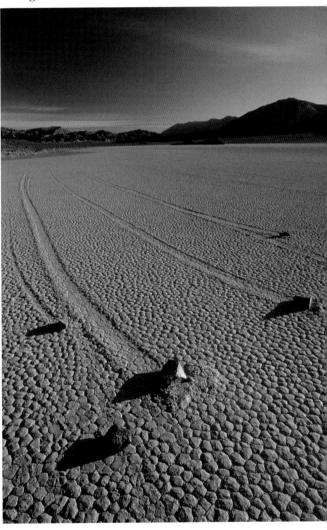

Another strategy is an overnighter at the Homestake Dry Camp, located at the playa's southern end. Heading out in midafternoon will enable you to actually *see* the road and ponder scenic potential along the way. A well-planned trip will permit scouting time and possibly a sunset shoot. The playa surface runs

Snowcapped Dry Mountain

Recommendations: Traveling safely means rarely exceeding 30 mph, with speeds often hovering in the 15 to 20 mph range. Budget at least three to three and a half hours to reach the playa from either Furnace Creek or Stovepipe Wells. If you wish to explore attractions along the way, remember to factor in additional time.

Cautions: Only attempt this trip if your vehicle is in good repair and you are able and willing to change a flat in rugged surroundings. Speaking of spares, you should carry a full-sized one that's properly inflated. Above all: the Racetrack is not a destination for passenger cars. I once overheard a ranger's response when a visitor asked if her front-wheel drive sedan was suitable for the trip. His colorful but cautioning response, "For you, it would be a four-wheel alignment road, but more likely it would destroy the car's suspension beyond a financially worthwhile repair. And that's if you don't need to be towed out." Weather can be an issue, too. Storms and flash floods are common. Additionally, the route passes through elevations high enough to collect snow and ice.

Directions: Proceed toward Ubehebe Crater, but instead of bearing left toward the parking area, take the dirt spur to the right. This 28-mile stretch of washboard gravel is best negotiated by high-clearance vehicles; 4WD capability is highly recommended and some-

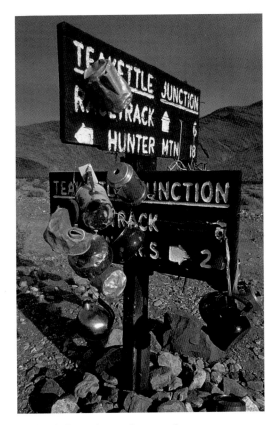

Teakettle Junction and namesakes

times required by road conditions. About 9 miles in, the road meanders through a Joshua tree forest, and Dry Mountain is visible to the north. Teakettle Junction is another 10 miles farther on.

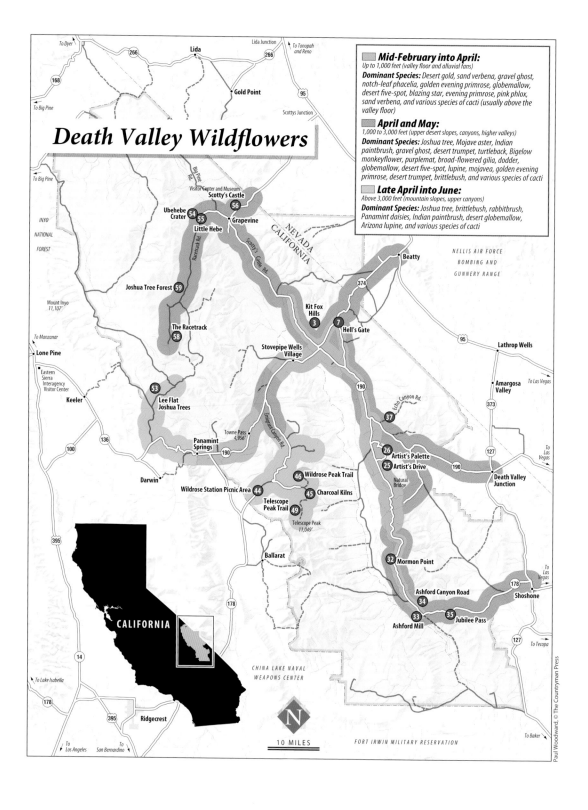

Death Valley Wildflowers

Mid-February into April:
Up to 1,000 feet (valley floor and alluvial fans)
Dominant Species: *Desert gold, sand verbena, gravel ghost, notch-leaf phacelia, golden evening primrose, globemallow, desert five-spot, blazing star, evening primrose, pink phlox, sand verbena, and various species of cacti (usually above the valley floor)*

April and May:
1,000 to 3,000 feet (upper desert slopes, canyons, higher valleys)
Dominant Species: *Joshua tree, Mojave aster, Indian paintbrush, gravel ghost, desert trumpet, turtleback, Bigelow monkeyflower, purplemat, broad-flowered gilia, dodder, globemallow, desert five-spot, lupine, mojavea, golden evening primrose, desert trumpet, brittlebush, and various species of cacti*

Late April into June:
Above 3,000 feet (mountain slopes, upper canyons)
Dominant Species: *Joshua tree, brittlebush, rabbitbrush, Panamint daisies, Indian paintbrush, desert globemallow, Arizona lupine, and various species of cacti*

10 MILES

Death Valley Wildflowers

Patience, tenacity, and resourcefulness are key characteristics of all desert plant life, especially wildflowers. Inherent to each species is a time-tested survival strategy, and when conditions allow, they transform Death Valley's barren browns into a carpet of color. In the desert, rain makes or breaks the wildflower season, though temperatures play an important role as well.

Wildflower Overview

As a rule, a winter of mild temperatures and well-spaced gentle, soaking rainfall followed by a subdued spring-to-summer transition bodes best for desert wildflowers. El Niño patterns are

Gravel ghost

Mid-February into April: Below sea level to 1,000 feet (valley floor and alluvial fans)
 Recommended Areas: Along \CA 190 from Furnace Creek to Scotty's Castle Road, Artist's Drive, Ashford Mill and Canyon, Badwater Road culverts (from Artist's Drive to Jubilee Pass), Beatty Cutoff Road, Furnace Creek Visitor Center, Mormon Point, Mud Canyon, Scotty's Castle Road near Kit Fox Hills
April and May: 1,000 to 3,000 feet (alluvial fans to lower foothills)
 Recommended Areas: Along CA 190 from Furnace Creek Wash to Death Valley Junction, Daylight Pass, Jubilee Pass, Salsberry Pass, Scotty's Castle Road (from Titus Canyon to the Castle), Racetrack Road, Ubehebe Crater
Late April into June: Above 3,000 feet (foothills and flats to upper Panamint Range)
 Recommended Areas: Charcoal Kilns, Emigrant Canyon Road, Lee Flat, Telescope Peak Trail, Wildrose Peak Trail
Wildflowers on the web: Death Valley National Park: www.nps.gov/deva/ NOAA: www.elnino.noaa.gov/ Desert USA: www.desertusa.com/

known to foster such conditions, and their presence is often linked to abundant Death Valley wildflower spreads. Weather agencies such as the National Oceanic and Atmospheric Administration (NOAA) regularly monitor such patterns. In addition, such resource sites as Desert USA collect and post regular updates about rainfall and blooming patterns throughout the Desert Southwest. Regardless of any year's precipitation pattern, some general rules of thumb apply for locating flowers in Death Valley:

Globemallow

Wildflower Photography Tools and Tips

To portray the showy details of desert wildflowers, you'll need specialty close-up gear, an adaptable tripod, a steady subject, and tasteful lighting conditions.

Close-Up Gear

Macro lenses are designed specifically for close-up application. They contain extremely high-quality glass and come in a variety of focal lengths and magnifications. Besides dedicated macro lenses, the most common accessories used for close-up flower photography are extension tubes and diopters. Extension tubes are hollow metal rings that fit between a primary lens and camera body. When attached, they enable a lens to focus closer than its normal minimum focusing distance. There are some great buys to be had on used extension tubes, but you'll need to research which models offer the most capabilities for your camera body, to score the sweetest deals. Diopters attach to the front lens element much like a filter. With no placeholder between the lens connection and camera body, through-the-lens (TTL) metering functions should remain intact.

Tripod and Cable Release

Ensure sharp, quality flower images by steadying your camera on a tripod. Peer through the viewfinder and wait patiently until the subject immobilizes. When it does, trip the shutter using a cable release. Engaging a camera's mirror lock-up or shutter delay feature is another way to reduce vibration.

Light Modifiers

Bright, overhead light is rarely the best for flower photography—but it's often the norm in Death Valley. Thankfully, light modifiers such as **diffusers** and **reflectors** are wonderful options for crafting complimentary flower set-

Identify drainage patterns: Washes and low-lying areas that may collect standing water are great places to begin. In fact, roadside gullies might be the *only* spots to feature flowers during stingy rainfall periods. Similarly, a convergence of autumn rainfall and modest temperatures may cultivate untimely winter blooms.

Consider elevation: Higher altitudes and northwestern slopes are likely to enjoy more generous precipitation and saturation opportunities. With park elevations ranging from below sea level to over 10,000 feet, flowers can bloom from February into June. Of course, what actually blooms and when is dependent on Mother Nature.

Knowledge is power: Routinely scanning the Death Valley Morning Report and Desert USA during December and January is a great way to gauge the upcoming flower year—especially important if your trip's sole focus is flower photography.

Timing is everything: Even in anomalous flower years, the peak window may only last a few weeks. This is especially true at lower elevations.

tings. A diffuser balances overhead light by reducing harsh shadows and hot spots, much like passing clouds. Alternately, reflectors add brightness to subjects by bouncing luminosity into a scene.

Wildflower Field Guide

While this seems like a no-brainer, having additional criteria to determine what you're shooting is never a bad thing. Suppose your best shot of a certain plant is an abstract macro image. Days, weeks, or months later when you try to recall it for keywording purposes, you'll be glad you have your field guide and shooting notes.

Composition Strategies

Desert wildflowers are fragile and often tiny. Bound together across a drainage basin, their chroma quotient appears more potent than up

Desert five-spot

Death Valley mojavea

close and personal. And sometimes it's tough to find a stellar blooming specimen. Don't take it personally; this is simply Mother Nature's grand design. To spawn the next generation, desert plants frequently display their full flowering process all at once: bud, blossom, and seed.

Survey the terrain for color and plants you find appealing. You'll also want to take notice of the lighting conditions and wind patterns. Optimum conditions for wildflower photography are days with high overcast clouds and no wind. Subdued lighting saturates color and enhances detail while fashioning muted backgrounds. The more protected your subject, the less likely that wind will hinder your images. When composing for flower close-ups, consider the quality of the background. Engage your camera's depth-of-field preview button to identify annoying intruders such as hot spots and miscellaneous foliage. When packing your gear, add a small piece of foam or a gardening pad to support your knees on rocky surfaces, which will allow you to concentrate longer on composition.

No doubt it's easy to be consumed by

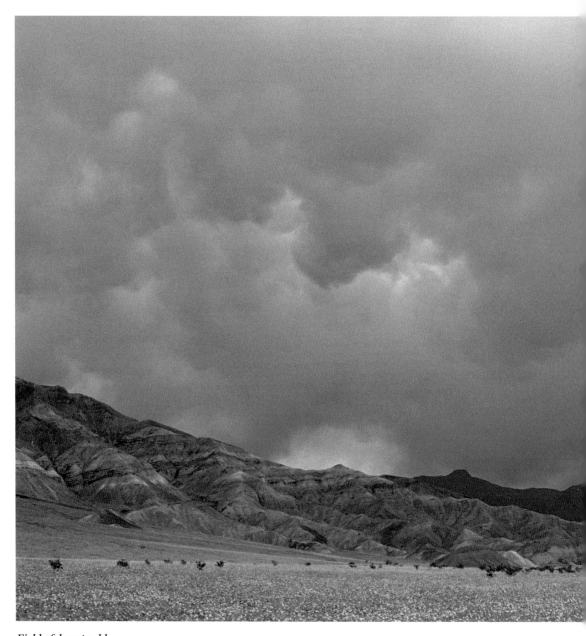

Field of desert gold

blossom intricacies—and by all means keep shooting if the wind and light are cooperative. If—or, more likely, *when*—the elements shift, ponder capturing environmental scenes. There are numerous ways to have fun with wildflow-ers, and this is certainly where the strength-in-numbers concept comes into play. To add depth to your composition, try adding flowers to the foreground. If it's particularly windy, consider letting the flowers blur. Make the

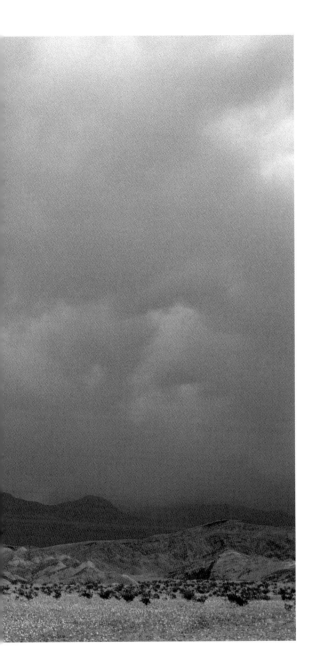

Using a telephoto or long focal-length lens to shoot flowers is another effective approach. Work with shallow apertures (low-numbered f-stops) and consult the depth-of-field preview button as you focus in and out to select your subject. Staying close to the ground may enable you to incorporate the sky and other washes of solid color as velvety backgrounds.

Desert gold close-up

most of the opportunity with long shutter-speeds and/or multiple exposures. Craft multiple depth-of-field looks from the same scene by experimenting with different f-stops and placement of your camera relative to the ground.

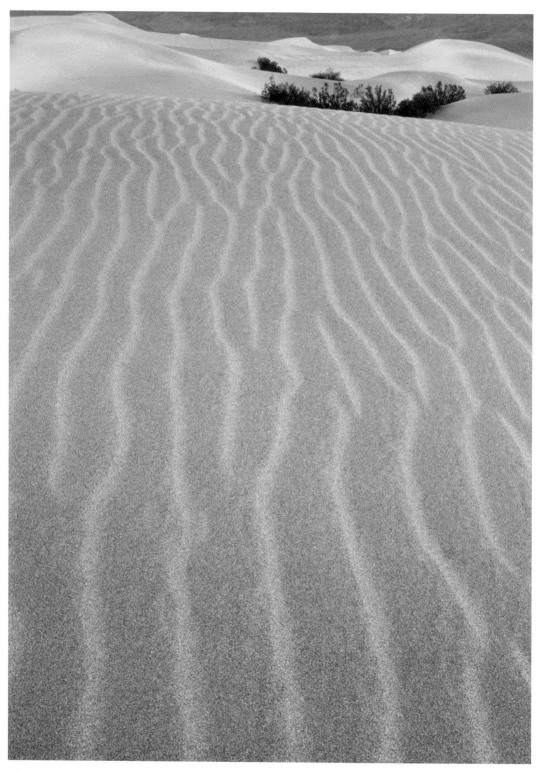

Mesquite Flat Sand Dunes

Most Published Images

Aguereberry Point
Badwater Reflections
Dante's View
Salt Pan Polygons
The Racetrack

Personal Nonphoto Favorites

El Cancun 2 Restaurant, Pahrump, Nevada
Ensenada Grill, Beatty, Nevada
Mahogany Flat Campground
Panamint Springs Resort Restaurant and Bar
Stovepipe Wells Swimming Pool

Scotty's Castle

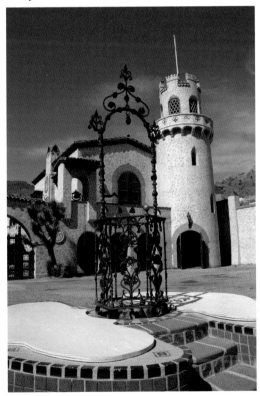

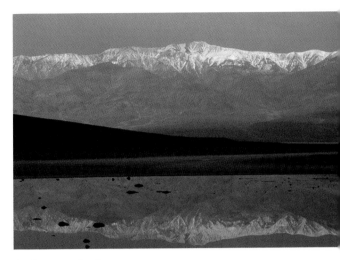

Badwater reflection

Favorite Structures and Cultural-History Subjects

Ashford Mill
Borax Museum
Charcoal Kilns
Rhyolite
Scotty's Castle

Favorite Hikes

Golden Canyon
Red Wall Canyon
Telescope Peak
Ubehebe Crater Trail
Wildrose Peak

Favorite Textural Subjects

Badwater Salt Pan
Devil's Golf Course
Golden Canyon
Mesquite Flat Sand Dunes
The Racetrack

Above: Sunset at Devil's Cornfield; below: Badwater Salt Pan

Personal Favorites

Badwater Salt Pan
Chuckwallas
Devil's Golf Course
Mahogany Flat Campground
Mesquite Flat Sand Dunes
The Racetrack

Favorite Sunsets

Artist's Drive and Artist's Palette
Devil's Cornfield
Devil's Golf Course
Father Crowley Point
Mesquite Flat Sand Dunes

Favorite Sunrises

Ashford Mill
Badwater Salt Pan
Dante's View
Mesquite Flat Sand Dunes
Zabriske Point

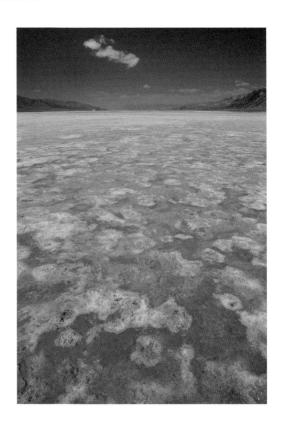

Resources

Beatty Chamber of Commerce
775-553-2424 or 866-736-3716
www.beattynevada.org

Death Valley Chamber of Commerce
760-852-4524
www.deathvalleychamber.org

Death Valley National Park
760-786-3200
www.nps.gov/deva

Death Valley Natural History Association
800-478-8564
www.dvnha.org

Furnace Creek Inn & Ranch
760-786-2345
www.furnacecreekresort.com/

Goldwell Open Air Museum
702-870-9946
www.goldwellmuseum.org/

Pahrump Valley Chamber of Commerce
775-727-5800 or 866-722-5800
www.pahrumpchamber.org

Panamint Springs Resort
775-482-7680; Fax: 775-482-7682
www.deathvalley.com/psr/
panamint@starband.net

Scotty's Castle Tour Information
760-786-2392

Eastern Sierra InterAgency Visitor Center
760-876-6222
www.fs.fed.us/r5/inyo/contact/#vc

Stovepipe Wells Village
760-786-2387
www.stovepipewells.com/

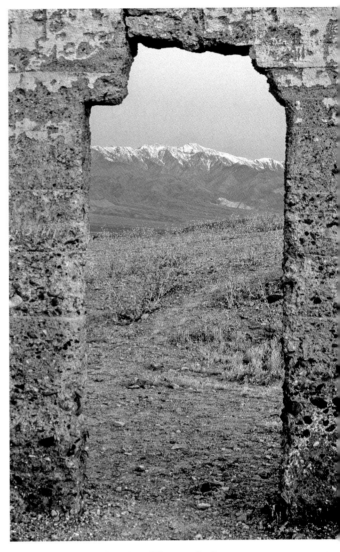

Ashford Mill ruins framing Telescope Peak

Death Valley Ranch

Suggested Reading

Death Valley Wildflowers by Roxana S. Ferris (Death Valley Natural History Association, 1981)

Deserts (Audubon Society Nature Guides) by James MacMahon (Knopf; Chanticleer Press edition, 1985)

The Explorer's Guide to Death Valley National Park by T. Scott Bryan and Betty Tucker-Bryan (University Press of Colorado, 1995)

Flowers and Shrubs of the Mojave Desert by Janice Emily Bowers (Western National Parks Association, 1998)

John Shaw's Nature Photography Field Guide by John Shaw (Amphoto Books, 2000)

Mojave Desert Wildflowers by Pam MacKay (Falcon, 2003)

Trails Illustrated Map of Death Valley National Park by National Geographic (National Geographic Maps, 2006)